AN ARTIST'S JOURNEY OF
DISCOVERY

BY CONSTANCE DEL VECCHIO/MALTESE

PREFACE by Constance Del Vecchio/ Maltese
INTRODUCTION by Anne Paolucci

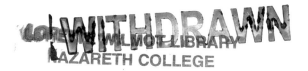

This book was made possible in part by a grant from
THE BAGEHOT COUNCIL
(a not-for-profit educational foundation)

Library of Congress Cataloging-in-Publication Data

Maltese, Constance Del Vecchio
 An artist's journey of discovery / by Constance
Del Vecchio Maltese; preface by
Constance Del Vecchio Maltese; introduction
by Anne Paolucci.
 p. cm.
 ISBN 0-918680-89-1 (cloth)
 1. Maltese, Constance—Themes, motives.
 2. Explorers in art. I. Title.
With illustrations: 32 black/white photographs, 55 color
photographs, 8 drawings.

ND237.M2325 A4 2000
759.13-dc21 00-059888

Published for
THE BAGEHOT COUNCIL
by
GRIFFON HOUSE PUBLICATIONS
1401 Pennsylvania Avenue, Wilmington, DE 19806

CONTENTS

INTRODUCTION

I was delighted when Constance Del Vecchio Maltese asked me to write an introduction to this volume. My interest in her work and in this book is not a casual one.

I encouraged her for some time to make prints of the "Age of Discovery Navigators" series available in a book, together with reproductions of her other recent paintings, as an important record of her artistic activity. Aside from my personal esteem for Connie and my admiration of her work, I felt that such a book would help insure the kind of professional recognition she so richly deserves. In addition to providing an excellent account of her extraordinary transformation from a successful commercial artist into a unique, truly exciting portrait painter, such a collection would also be an important contribution to the archives of the Columbus quincentenary. What she has prepared is a work of art in itself — a fine sampling of reproductions spiced with humorous, self-effacing anecdotes.

Connie had done portraits before, but, in my opinion, nothing as striking as the "Navigators" series (launched in 1988 under the auspices of "Columbus: Countdown 1992") and the "American Women" portraits that followed. Connie herself has told the story of how the first Columbus painting came about. I will only underscore our initial surprise, the pleasure my husband and I derived from seeing that first painting, where the artist had researched even border designs of the period to create a 'frame' for what came to be known as "the young Columbus." Inside that 'frame' the artist had provided 'highlights' and significant 'icons' relating to the life of Columbus — the hull of the Santa Maria, Queen Isabella in profile looking across the canvas to the profile of a native of the 'Indies,' the outline of Italy, where Columbus was born.

My husband and I wondered at the time: What else can she possibly add to this accomplishment?

In due course, she created twelve more canvases, each depicting a major navigator or explorer of the time, each painting distinct, original and exciting.

She tells us she used real people as models. And many of them are indeed recognizable, since they were drawn from among friends and colleagues. But in each case, Connie infused those familiar countenances with expressions that reflected the particulars of the story behind her *historical* subject. The result was a happy combination of contemporary faces and Renaissance personalities.

It was that novel approach that first struck me about the "Navigators" series. I knew Connie had done something extraordinary in juxtaposing the past and the present in the faces she portrayed, creating a new kind of contemporary portraiture. That approach, and her signature 'highlights' (reminiscent of landscapes and distant scenes in Renaissance "Anunciations" and portraits), were carried over into her second series featuring "American Women."

The subjects in this series, unlike the navigators of the "Age of Discovery" series, were very much alive. They were women Connie herself had singled out for their significant contributions. They represented a wide spectrum of professions: legislators, educators, philanthropists, even a woman astronaut. Each woman was depicted in her characteristic and recognizable setting and, wherever possible, shown *in action*. This was indeed a fresh departure from the usual portraits, where the subject seems to be frozen in time, staring out into space. Here too, 'highlights' were given subdued but careful attention, often serving as a 'frame.' I found this approach especially refreshing.

Each painting in this series is distinct; and although familiar stylistic features can be recognized in all of them, some are lively and colorful while others suggest a darker, brooding quality.

I have no doubt in my mind that whatever else

Constance Del Vecchio Maltese will paint in the future, she will continue to surprise us. She has discovered in herself a world that is as various and new as the Renaissance itself. Her vision and skill, applied with enthusiastic sensibility to a traditional medium, reminds me of Cimabue and Giotto, who first reclaimed the world of nature for art, articulating joy and suffering through recognizably human faces, depicting, in those memorable paintings, human frailty tempered by a rediscovered sense of hope, faith, and love.

Having said this much, I realized that I haven't said enough. But words in themselves will never be enough. One has to see the paintings to fully appreciate what they represent and how original and interesting a style the artist discovered for herself.

The reproductions in this book will attest to what I have tried to approximate through words.

ANNE PAOLUCCI
FEBRUARY 29, 2000

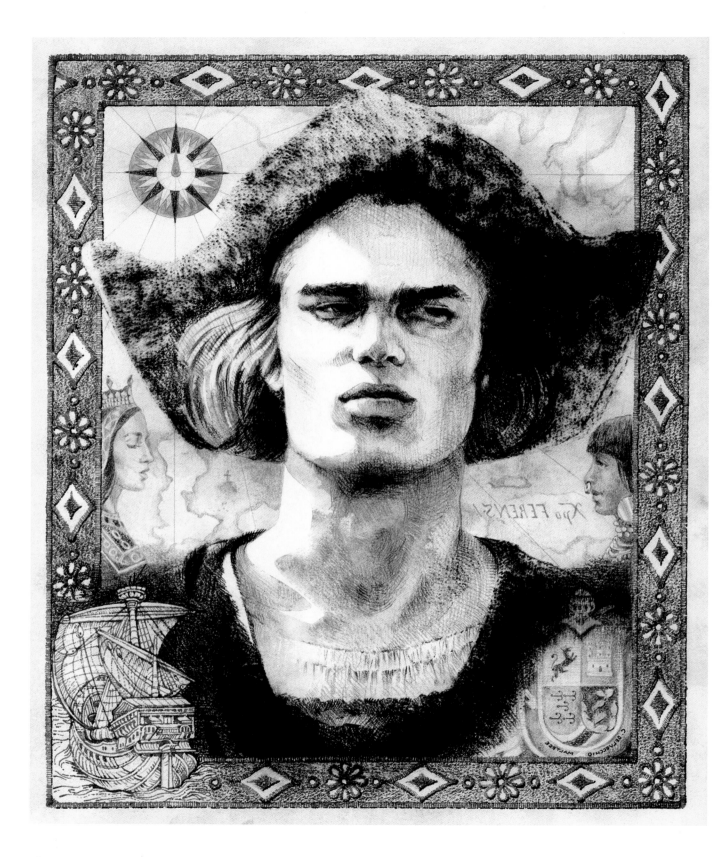

A STRONG-JAWED LIGURIAN VISIONARY SEEING HIS DREAM WITH DETERMINED INTENSITY THROUGH THE REALITIES OF THE WORLD

YOUNG VISIONARY 1

So named because he is the 29-year-old Genoese Columbus — the one who has a dream and a burning ambition to find the rich land Marco Polo wrote about. He is yet to see Queen Isabella and set upon his mission.

Since no one really depicted Columbus in his own time, there are many faces painted of Columbus, all differing one from another. The only certainty was what Columbus' son Ferdinand wrote of his father in later years. "My father was a fine figure of a man, blond, blue-eyed and turned completely gray in his mid thirties." Armed with this information, I set about creating an image that would bring Columbus into the 20th century — so that people today, seeing him, would relate to him as a contemporary.

After many pencil sketches, without the bene-fit of a model, I decided to show the character of the man in his face. To do that it would be necessary to read about him. Since all I really knew about Columbus was his name and 1492, Dr. Henry Paolucci, who I called the Professor, recommended "Admiral of the Ocean Sea" by Samuel Eliot Morison.

While reading this, many other books were brought to my attention — six in particular.

> ### *I was astonished when I looked at his face and realized that subconsciously I had drawn him!*

Some were written recently, others approxi-mately a hundred years ago. Not all were complimentary, but when I finished reading there were certain consistencies. *Strong, deter-mined, perservering, and a strong sense of honor and love of God* were characteristics undeniably repeated over and over again.

Having him face full front created a strong virile image with a square jaw, bold muscular neck and broad shoulders. He looks to his right with teeth clenched, envisioning the beckoning sea while under full sail. A ray of sun striking his head on one side reveals light hair under his hat.

When I was satisfied that the look was right, I began to consider what Dr. Paolucci would think. Would it be too contemporary? Would it lack the seriousness necessary to treat him (Columbus) as a historical figure? Therefore, I decided to combine past with present by surrounding him with a tapestry of his life.

One evening, while sketching a pencil draft of the Young Visionary, Serf, my husband, looked over my shoulder to see what I was doing. I was obviously enjoying myself and he remarked, "You like him, don't you?" Oddly enough, he sounded jealous. I said flippantly, "What's not to like?" About a month later I was going through some old pictures for a political brochure my husband was putting together for his upcoming campaign and came across an old photograph of Serf. I was astonished when I looked at his face and realized that subconsciously I had drawn him. My young visionary was Serf! I quickly went to Serf and said, "Look who you were jealous of. I did you!!" ➡

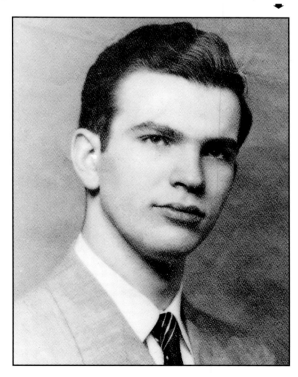

The finished charcoal drawing was worked on an antique map which I simulated, clearly showing the boot of Italy in the upper left corner. A navigational rose is in the upper right. Flanking his left and right are Queen Isabella and a Native American woman proudly wearing much of her jewelry. The "Xpo FERENS" was his half–Greek, half–Latin signature meaning "Christ Bearer," which he used on many of his documents. The coat of arms was bestowed on him by Queen Isabella after his landing in the Americas. A woodcut of the Santa Maria is set into the frame, which is an authentic design used on the robes of the time.

Now it was ready for COLUMBUS: COUNTDOWN 1992! I carried my painting to the Pauluccis, not knowing if this would sail or not. However, after standing the painting (18x24) on the sofa and unceremoniously unveiling it, Professor Henry Paolucci, Anne's husband, shouted aloud, "Look, Anne, what she's done!" — pointing to Xpo FERENS. He had apparently just finished a paper on the signature and was delighted that I had included it on the portrait. So with a sigh of relief,

I began to explain how I arrived at this final result. It is a multi-media painting; that is, any means to create this effect was used. Pen and ink, charcoal, acrylic, water color, oil, pencil, and pastels were all employed on this journey.

They were happy with the composition of facts and portrait and suggested, "Wouldn't it be nice if you did a series just like this of the Discoverers?" Thinking of how long it took to arrive at this (reading the books, researching the coat of arms, the designs, etc.) and the library time put in to insure authenticity, I calculated at least four to five months, in addition to the time needed for the art work (another 3 months). My response was a grin and a weak nod.

Since I was still accepting contracts to draw for children's text workbooks, I was working the Columbus drawing in between. I would soon have to turn down any further commitments to have time for my Discovery.

In October 1989 I was given the "Special Recognition in the Arts and Humanities" Award from COLUMBUS: COUNTDOWN 1992 to further fuel my "Journey of Discovery."

Portrait: CHRISTOPHER COLUMBUS "AGE OF DISCOVERY NAVIGATORS"
by Constance Del Vecchio/Maltese

LEGEND

The background is an ancient map including the "boot" of Italy (upper left) and a "compass rose" (upper right). At mid-right is Queen Isabella, who financed Columbus' voyage to America. Upon his success she bestowed on him the Coat of Arms (lower left). "Xpo FERENS" to the left of Columbus is the signature that Columbus used, half Greek and half Latin, meaning "Christ-bearer." At the lower right on the border is a wood cut of the "Santa Maria." The border itself is an adaptation of an authentic design used on clothing of the times. Columbus died in Valladolid, Spain, on May 20, 1506.

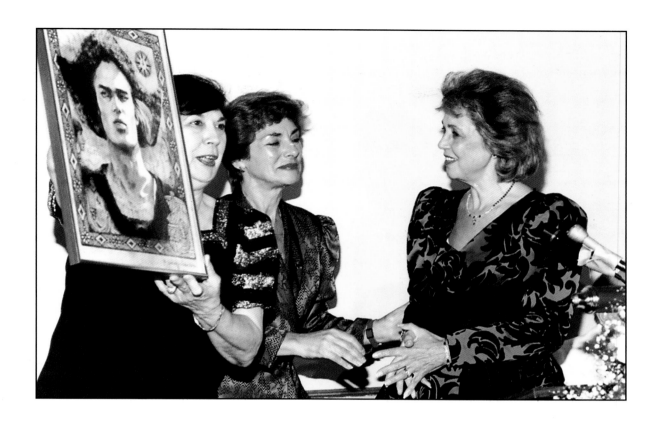

Columbus Countdown Dinner 1989

Dr. Anne Paolucci holds the first print of the "Young Visionary" to be presented to then First Lady of New York, Matilda Cuomo.

Constance Del Vecchio/Maltese addressing the guests at the dinner after Dr. Paul Patané, right, responds to thanks for a glowing introduction.

First Print Young Visionary Presented to New York First Lady Matilda Cuomo

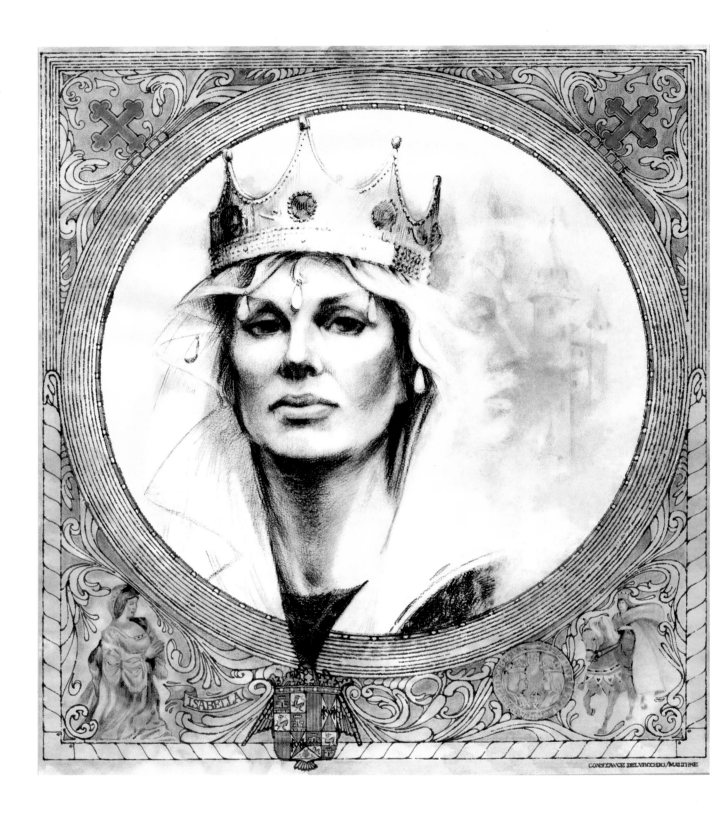

ENERGETIC, AMBITIOUS AND MULTI-FACETED, QUEEN ISABELLA IS PICTURED – FULL FACED AND IN SHADOW — WITH HER "FAVORITE CASTLE" IN SEGOVIA. WITH CHURCH DISPENSATION, ISABELLA MARRIED HER SIXTEEN-YEAR-OLD COUSIN FERDINAND WHEN SHE WAS SEVENTEEN

CAROL MONTE

I was born in 1944, the fourth daughter of five children. My parents were Norwegian immigrants. I grew up in Queens, New York and graduated from Jamaica High School. While I was in school, I worked part-time in the local supermarket. After school I worked in a bank in Manhattan and did some photographic modeling. At that time I was invited to enter the Miss Universe Pageant. I was flattered but not interested enough to pursue it.

Thirty-four wonderful years ago I married Paul, the man who moved in across the street from me. We have three devoted children: Francesca, Sabena, and Sebastian. We have four darling grandchildren: Christopher, Nicholas, Gianna and Salvatore. We are a close and loving family and cherish the time we spend together.

Presently, Paul and I have two residences. Weekdays we live in the "Monte Excelsior" apartment building in northeast Queens. It is one of the buildings built and owned by my husband's family. Some of my time is spent at the family-owned restaurant, Harpers. Weekends are spent at our home in Smithtown. Our property abuts a 600-acre county park, where we can ride and enjoy our three horses.

I am quite creative, and design and make many of my own clothes. I enjoy refinishing furniture, gardening, board games and puzzles. I have a soft spot in my heart for all God's creatures.

I have two mottoes that I live by that were instilled in me from childhood by my father. The first is: "If you want anything done, do it yourself." The second: "Being beautiful will open many doors for you. What is important is what you do once you get in."

Lastly, I thank God for all my friends and family. I'm thankful for my mother-in-law whom I adore and would like to emulate. But mostly I am thankful for the person who is my husband, lover, and best friend all in one, Paul.

CAROL MONTE

I was born in 1944, the fourth daughter of five children. My parents were Norwegian immigrants. I grew up in Queens, New York and graduated from Jamaica High School. While I was in school, I worked part-time in the local supermarket. After school I worked in a bank in Manhattan and did some photographic modeling. At that time I was invited to enter the Miss Universe Pageant. I was flattered but not interested enough to pursue it.

Thirty-four wonderful years ago I married Paul, the man who moved in across the street from me. We have three devoted children: Francesca, Sabena, and Sebastian. We have four darling grandchildren: Christopher, Nicholas, Gianna and Salvatore. We are a close and loving family and cherish the time we spend together.

Presently, Paul and I have two residences. Weekdays we live in the "Monte Excelsior" apartment building in northeast Queens. It is one of the buildings built and owned by my husband's family. Some of my time is spent at the family-owned restaurant, Harpers. Weekends are spent at our home in Smithtown. Our property abuts a 600-acre county park, where we can ride and enjoy our three horses.

I am quite creative, and design and make many of my own clothes. I enjoy refinishing furniture, gardening, board games and puzzles. I have a soft spot in my heart for all God's creatures.

I have two mottoes that I live by that were instilled in me from childhood by my father. The first is: "If you want anything done, do it yourself." The second: "Being beautiful will open many doors for you. What is important is what you do once you get in.".

Lastly, I thank God for all my friends and family. I'm thankful for my mother-in-law whom I adore and would like to emulate. But mostly I am thankful for the person who is my husband, lover, and best friend all in one, Paul.

QUEEN ISABELLA 2

After the completion of the Young Visionary, I was ready to do the female counterpart, the lady who made the journey possible, the one who by all accounts was not only his financial backer but also a moral supporter.

She was never a woman to give in easily to adversity or confrontation*, as one might guess from reading the history of the wars that finally made her the undisputed ruler of Castile. Even as a girl of sixteen she had a strong determination and will of her own. Her mother had thought of Isabella marrying someone other than Ferdinand; after all, he was a first cousin and a mere child of fifteen himself.

Isabella, however, perservered, viewing herself of Castile and Ferdinand of Aragon as the fusion of two powers creating a unified Spain. She obtained special dispensations from the church to marry her cousin, as she was a devout Catholic, and they were wed in 1469. She was seventeen and he was sixteen. Being Castilian, I was surprised to find out that she was a strawberry blond with blue-green eyes and skin that freckled easily.

I had just finished reading this fascinating history of Isabella when I was asked to display the painting of my Young Visionary at the Columbus Club Dinner for the Columbus Day Celebration at the Waldorf Astoria Hotel. It would be presented at the reception before the dinner and Governor and Mrs. Cuomo would be attending. I was thrilled at the prospect of having my Young Visionary attend such a prestigious function and did not hesitate to accept.

Both my young Columbus and myself were located before the reception hall, so as the line of people filed through to go into the reception area, "Chris" and I acted as kind of

a receiving line. In came the Governor and his wife. I smiled, they nodded, and a long procession followed behind them. About a third down the line I spied a statuesque blond woman wearing a black lace gown with a matching Mantilla-like scarf on her head. "My God," I thought, "She could be Queen Isabella!"

She approached, her eyes on the painting, and turned to me as she started to file past. "You know," she said as she stopped beside me. "I noticed your Columbus when I first came in." I said the feeling was mutual as I had noticed her when she first walked in, and I told her that I thought that she would be a terrific Queen Isabella. She wasted no time in asking, "When do you want me to sit?"

Again destiny took a hand and I had my Queen Isabella. This was the first time I used

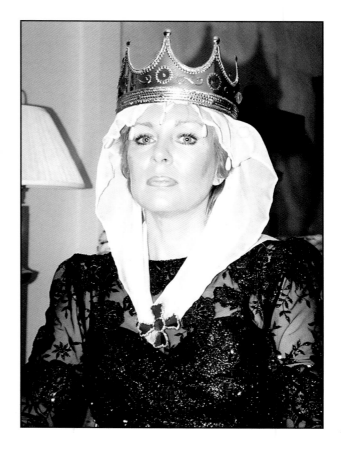

* "The History of the Reign of Ferdinand and Isabella"
 by William Hickbury Prescott

17

a model for the series. Her name is Carol Monte.

Carol came to my house for the first sitting in November 1989. I had purchased a crown befitting a Queen at a costume shop. (I wanted her to *feel* like a queen as well as *look* like one.) When comparing this crown with one from an old painting of Queen Isabella, I found that a cloth decorated with pearls should descend from the crown to create the illusion of the period. I cut up a voile curtain, attached a piece of it onto the crown, and went to the "ol' sewing box" to find suitable pearl drops to fall upon her brow.

We chatted while she sat. I told her about Queen Isabella's personal life. Among other things, the Queen was an excellent horsewoman and on horseback would visit the troops in the field. A smile came over Carol's face when she told me that she too rode horseback and in fact kept horses in a stable in Smithtown, Long Island. I literally got goose flesh all over.

The bone structure in Carol's face was strong and easily gave me the assured countenance I needed to create Isabella. Because she was such a multi-faceted woman, I decided to paint a profile beside the full view, giving the impression of a second personality.

It was 1486 when Cristobal Colon (Christopher Columbus) first approached Queen Isabella with his young son Diego. The Queen was engaged in a war and money was hard to come by, so it was years before she could commit to ships and supplies for the historic journey of 1492.

Through the years that followed, Queen Isabella remained Columbus' main, sometimes sole, supporter. Towards the end, she too began to doubt Columbus and had him arrested and brought back in chains, thinking he had kept the gold for himself. Hurt and angry, Columbus convinced her that this was not so, but she could not reinstate him, as other explorers had by then taken his place.

Portrait: QUEEN ISABELLA / "AGE OF DISCOVERY NAVIGATORS"
by Constance Del Vecchio/Maltese

LEGEND

Upper left and righthand crosses indicate Isabella's strong Catholic faith. On the lower left is a wooden statue of the Queen, who replaced the corrupt clergy with the educated and devout. The Coat of Arms is of Aragon and Castile. To the right is the currency created by her. Below, Queen Isabella rides horseback, as she was known to do to meet and cheer her troops at the front in their war against the Moors in 1482. Isabella died on November 26, 1504.

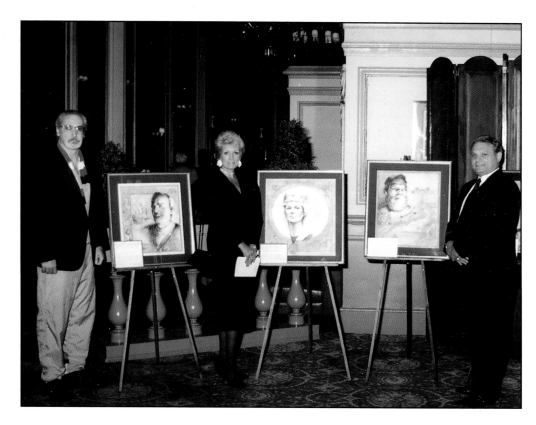

Left to right:
Thomas Ognibene
stands next to Vasco Da
Gama, Carol Monte
next to Queen Isabella,
and Judge Joseph Golia
next to Giovanni
Da Verrazzano.

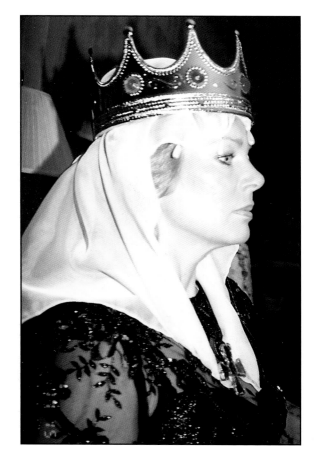

*Past meets the present
at the Columbus Countdown
Dinner 1990*

◀ Carol Monte poses in profile
so as to create the double illusion.

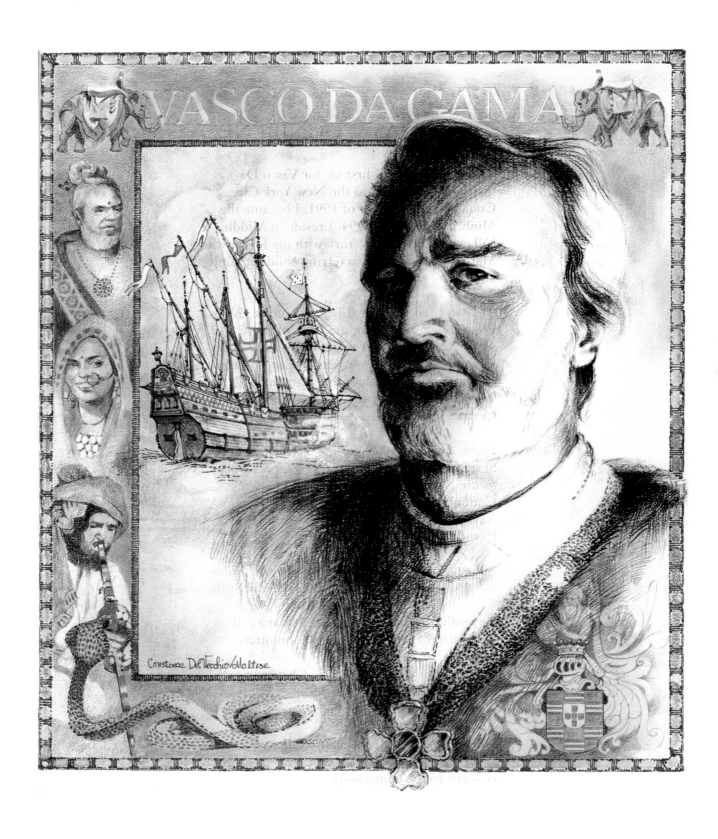

VASCO DA GAMA

Constance Del Vecchio Maltese

PICTURED IN FUR AND PROUDLY DISPLAYING AROUND HIS NECK THE "MILITARY ORDER OF CHRIST" BESTOWED UPON HIM BY DON MANUEL, KING OF PORTUGAL, WHO ALSO GAVE HIM THE COAT OF ARMS DEPICTED IN THE LOWER RIGHT BORDER

THOMAS V. OGNIBENE

An attorney when I first sat for Vasco Da Gama, I was elected to the New York City Council in November of 1991. I became the Minority Leader in 1994. I reside in Middle Village, Queens, New York with my lovely wife, Margaret, and have two terrific children, Guy and Eve.

In 1966 I was a Dean's List graduate at C.W. Post College, an honor graduate of the U.S. Army Armor School Officer Class in 1967 and served in the U.S. Army Armor Corps until 1970. A Brooklyn Law School graduate in 1974, I entered private practice of law in 1975, specializing in real estate law.

I served as Chief Counsel to State Senator Serphin R. Maltese and also served as Counsel to the New York State Senate Standing Committee on Veterans, the Senate Veterans' Advisory Council, and the New York State Committee on Consumer Protection.

Since 1979 I have been serving as a Pro Bono member of the Board of Trustees of Christ the King Regional High School and am currently Vice Chairman of the Board and Chairman of the Scholarship Committee.

I am presently Executive Vice Chairman and Executive Director of the Queens County Republican Party.

Whenever I can, I continue to donate services Pro Bono on issues of concern to the community.

THOMAS V. OGNIBENE

An attorney when I first sat for Vasco Da Gama, I was elected to the New York City Council in November of 1991. I became the Minority Leader in 1994. I reside in Middle Village, Queens, New York with my lovely wife, Margaret, and have two terrific children, Guy and Eve.

In 1966 I was a Dean's List graduate at C.W. Post College, an honor graduate of the U.S. Army Armor School Officer Class in 1967 and served in the U.S. Army Armor Corps until 1970. A Brooklyn Law School graduate in 1974, I entered private practice of law in 1975, specializing in real estate law.

I served as Chief Counsel to State Senator Serphin R. Maltese and also served as Counsel to the New York State Senate Standing Committee on Veterans, the Senate Veterans' Advisory Council, and the New York State Committee on Consumer Protection.

Since 1979 I have been serving as a Pro Bono member of the Board of Trustees of Christ the King Regional High School and am currently Vice Chairman of the Board and Chairman of the Scholarship Committee.

I am presently Executive Vice Chairman and Executive Director of the Queens County Republican Party.

Whenever I can, I continue to donate services Pro Bono on issues of concern to the community.

VASCO DA GAMA 3

The Portuguese, being the masters of the sea, produced one of its finest navigators in Vasco Da Gama, who set out to prove Columbus' theory of sailing west to reach Cipango was complete folly, and proceeded to sail east to reach his destination, India. I read this bit of information about Da Gama in a history book that referred to many navigators, but gave no further specific information.

In the spring of 1990 I was in Westerlo, New York, where Serf and I have a summer Lake House. I created a studio on a screen-enclosed porch. The light is great and the atmosphere condusive to concentrated work. I was ready for the next of the series and felt I had to move along quickly since I had committed myself to get fourteen or fifteen done by 1992, the Quincentennary. If they all took as long as the first two, I would be running a very tight deadline — which was amusing, since I thought I'd left deadlines behind when I left the commercial field.

I began my research of Vasco Da Gama with my library of *National Geographics*. The index listed a twenty-page story on Da Gama in the November 1927 issue. "Great!" I thought. "Just what I need!" I scanned the row of bound magazines and found that my earliest issue was

January 1928. I needed something of substance to start the research process — a coat of arms, his ships, people that he dealt with, etc. It was frustrating. I was ready but couldn't begin. If I was back in the city I could run to the library, but this was Westerlo on Sunday.

Serf meanwhile was reading the Sunday paper and noticed an ad for Cater's auction and flea market in the neighborhood. He made the point that since I couldn't do anything anyway, why not hit the flea market? We had spent many Sunday afternoons at this auction, anticipating wonderful finds and this turned out to be no exception. I was watching as they paraded great antiques (and junk) when Serf said he was going to the flea market section to look at the post cards (he loves old post cards).

Within ten minutes Serf returned holding a paper bag. He had a strange smile on his face when he sat down next to me and quietly put the bag in my lap. He nodded towards the bag and I opened it. I couldn't believe it! A November 1927 *National Geographic*. It contained "The Pathfinder of the East: Setting Sail to Find Christians and Spices, Vasco da Gama Met Amazing Adventures, Founded an Empire, and Changed the History of Western Europe" by J. R. Hildebrand!

"Who are you and state your business." He did so, thereby becoming a contemporary Vasco Da Gama.

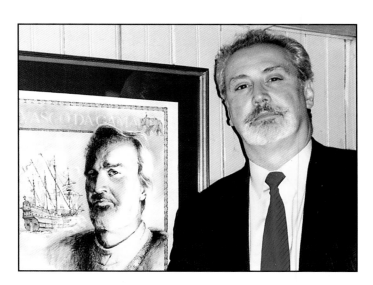

New York City Councilman Thomas V. Ognibene, model for Vasco, poses next to the portrait being exhibited at "Maspeth Town Hall."

Things began to fall in place. I soon obtained Da Gama's coat of arms from the Portuguese Embassy in Manhattan (along with a great deal of literature — all, alas, in Portuguese!).

Now all I had to do was find an appropriate model to be my Vasco Da Gama. This I found in the person of Thomas V. Ognibene, an attorney and a good friend. The Honorable Tom, Serf's counsel at the time, came to our home for a meeting. I stared at him — his nose, his beard, his eyes. I asked him to take off his glasses, and *voila!* Before me stood Vasco Da Gama!

Da Gama had claimed that Columbus had failed by going the wrong way. Da Gama attempted to correct that error by charting his vessel in a "saner" direction, as laid out by Prince Henry the Navigator. His voyage took him to India and made him a very wealthy trader and ultimately the Viceroy of India. The wealth and independent air of Da Gama gave him an arrogant demeanor that was quite apparent in the portrait of him that was, at the time, considered to be an authentic likeness of the voyager.

Tom sat for me the following week. He wore an old housecoat of Serf's and my heavy chain with a maltese cross – the "Military Order of Christ" medal founded in 1318 and bestowed on Da Gama. The only thing that needed changing was Tom's smiling face to one of arrogance. I asked him to pose without his glasses and raise his eyebrow as if to say, "Who are you? And state your business." Tom obliged by raising his eyebrow ever so slightly and thereby became a contemporary Vasco Da Gama.

Looking at Tom, I have a hard time not thinking of him as Da Gama. I like to believe that the experience for him created an alter ego that spirited him toward becoming the visionary that he is.

Portrait: VASCO DA GAMA • "AGE OF DISCOVERY NAVIGATORS"
by Constance Del Vecchio/Maltese

LEGEND

In mid-left section of painting, Da Gama's ship the St. Gabriel (one of three that sailed to India). Top right and left are Indian elephants. Directly under the left elephant is the "Zamorin," the ruler of India, shown wearing fine silks, gold and gems). Just below is an Indian lady wearing her wealth. On the bottom left is a snake charmer with a five-foot cobra. In his early fifties Da Gama was made Viceroy of India. He died on Christmas Eve 1524 in Cochin, a region in Indochina.

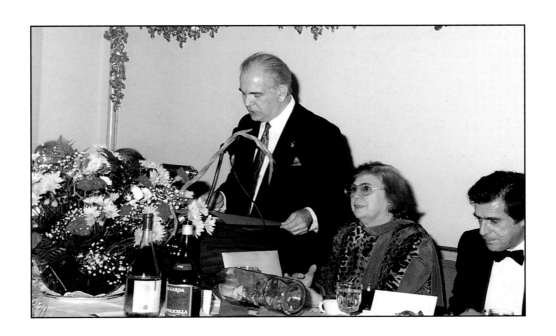

Columbus Countdown Dinner 1990

Senator Serphin R. Maltese
addressing the 1990 Dinner.
Dr. Anne Paolucci and
Dr. Moura are to his left.

A presentation from one Vasco to another.

Presentation to Dr. Vasco Graca Moura
of Portugal — writer,
playwright, poet and publisher.

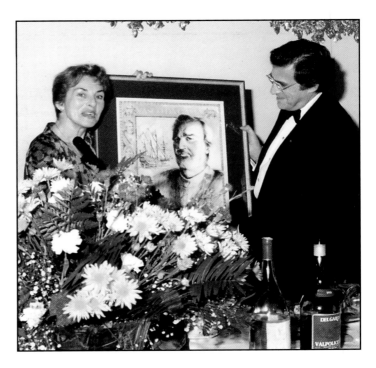

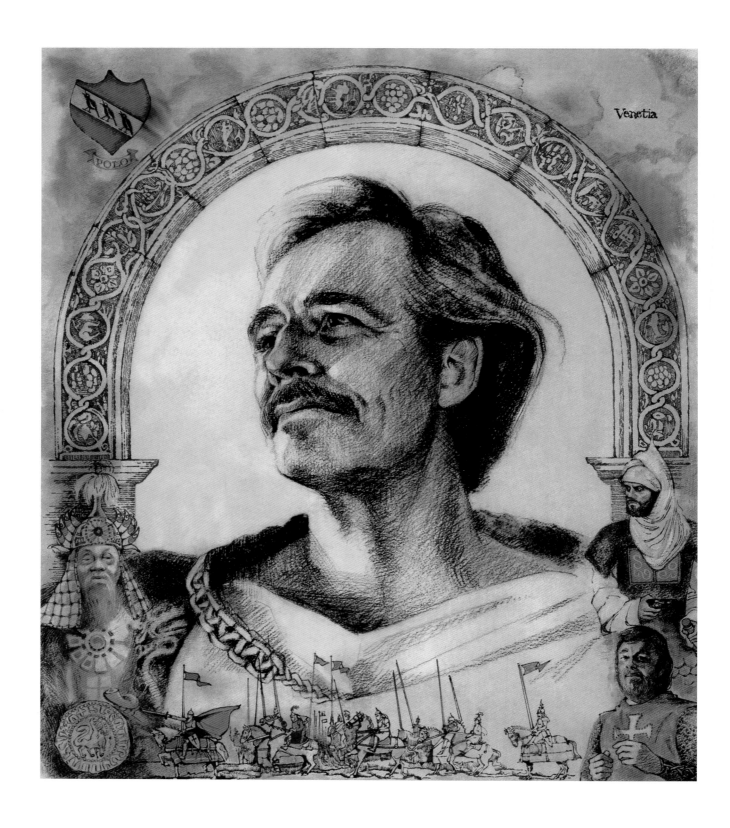

A PORTRAIT OF A BOLD, STRONG MAN OF VISION WHO SET THE STAGE FOR THOSE WHO WOULD FOLLOW HIS EXAMPLE. BORN IN VENICE IN 1254, MARCO POLO LEFT ITALY AS A YOUTH AND RETURNED TWENTY YEARS LATER AS A MAN OF THE RENAISSANCE

GEORGE NEMETH

George Nemeth was born in June of 1942 and must have been instilled with a work ethic that made it possible for him to later be dubbed the Genius Turnaround Artist by Crain's New York Business.

Nemeth was a Manhattan-based lawyer, private investor and financial consultant. In the early 1980s he helped reorganize and revive — then sell to Kraft — the Mineola, L.I.-based Pollio Dairy Products Corp. He then helped the small Albany commuter airline, Mall Airways Inc., get back off the ground after having violated federal aviation rules.

It was in 1991 when a friend, Republican State Party Chairman William Powers, came to him with a request to do for the Republican Party what he had done for corporations. He was appointed Party Vice Chairman and took on the challenge *pro bono*. Trying to raise at least three million dollars by the end of the following year put a new wrinkle to an old challenge.

During his association with the Republican Party, George Nemeth met Serf and Constance Maltese. Constance told him that it was his ability to see the possibilities of "what could be" that gave him the visionary attitude and twinkle in his eye that she was looking for. Hence he became Marco Polo, inventor of great tales and adventures, and had a lot of fun imagining himself as the daring traveler and visionary.

Nemeth moved in yet another direction. He had acquired a home on Shelter Island where, in the winter, the 2,000 year-round residents hunker down. Ferries from Greenport and Sag Harbor switch to off-season schedules and visitors who don't leave the island before the midnight boat can't leave until the next morning. To help offset seasonal "hibernation," George Nemeth, along with Dr. Vincent DiGregorio, started a winter Film Festival on Shelter Island. Yet another challenge!

Mr. Nemeth will most likely continue doing the impossible, because for him it is simply a way of life.

GEORGE NEMETH

George Nemeth was born in June of 1942 and must have been instilled with a work ethic that made it possible for him to later be dubbed the Genius Turnaround Artist by Crain's New York Business.

Nemeth was a Manhattan-based lawyer, private investor and financial consultant. In the early 1980s he helped reorganize and revive — then sell to Kraft — the Mineola, L.I.-based Pollio Dairy Products Corp. He then helped the small Albany commuter airline, Mall Airways Inc., get back off the ground after having violated federal aviation rules.

It was in 1991 when a friend, Republican State Party Chairman William Powers, came to him with a request to do for the Republican Party what he had done for corporations. He was appointed Party Vice Chairman and took on the challenge pro bono. Trying to raise at least three million dollars by the end of the following year put a new wrinkle to an old challenge.

During his association with the Republican Party, George Nemeth met Serf and Constance Maltese. Constance told him that it was his ability to see the possibilities of "what could be" that gave him the visionary attitude and twinkle in his eye that she was looking for. Hence he became Marco Polo, inventor of great tales and adventures, and had a lot of fun imagining himself as the daring traveler and visionary.

Nemeth moved in yet another direction. He had acquired a home on Shelter Island where, in the winter, the 2,000 year-round residents hunker down. Ferries from Greenport and Sag Harbor switch to off-season schedules and visitors who don't leave the island before the midnight boat can't leave until the next morning. To help offset seasonal "hibernation", George Nemeth, along with Dr. Vincent DiGregorio, started a winter Film Festival on Shelter Island. Yet another challenge!

Mr. Nemeth will most likely continue doing the impossible, because for him it is simply a way of life.

MARCO POLO 4

Marco Polo inspired Christopher Columbus. Even though Polo was born many years before Columbus — in 1254, Columbus had read of Marco Polo's adventures and his discovery of different lands and cultures. I'm sure Columbus had these stories in mind when he started dreaming of his own voyage.

Columbus had differences with the maps that Marco Polo utilized, certain there was less distance involved in the separation of lands. However, the concept was an inviting one and spurred Columbus into pursuing a challenge that will forever be remembered. Therefore, it seemed only natural to include Marco Polo in my "Discovery" series.

Marco Polo left his homeland at the age of seventeen with his father and uncle, Nicolo and Maffeo, and returned twenty years later as a Renaissance Man.

Polo's adventures were many — he aided the Kublai Klan in the defeat of the Moslems, acquainted the Kublai with Christianity through the teachings of Pope Gregory X, and, since there was no communication between territories (no telephone or fax), it was Marco Polo 's duty to keep the Kublai informed with news from various tribes, groups and peoples.

Marco Polo had been imprisoned in Genoa during one of Venice's skirmishes with that city. Rustichello, it appears, was something of a small-time romance writer who contributed to a thirteenth-century version of *Ladies Home Journal*. It was he who put into writing Marco Polo's "The Travels," originally entitled "A Description of the World."

Marco was such a great story teller – and sometimes embellished the truth by slightly stretching it to make a more interesting plot. It seemed to me that such a great spinner of tales would not only be able to entrance others, but also enjoy them himself. Such enjoyment would certainly be evidenced in his countenance with a slight twinkle in the eyes.

Mr. George Nemeth came to mind. Not because of the tall tales, but because of the twinkle in the eyes. George Nemeth, owner and president of Polly-O Cheese and founder of a small airline, never found problems with new ventures and challenges. He seemed a natural and obvious choice for Marco Polo.

George very kindly consented to pose for Marco Polo and came to my home in March 1990 to begin. We created a costume with a sheet, my husband's velour bathrobe, and a decorative braid from a Marine uniform.

That twinkle in his eye and his windblown hair helped to create a dynamic vision of Marco Polo. TERRIFIC!

George Nemeth posing as a strong and vibrant Marco Polo. Only a slight exaggeration was used for a wind-blown look.

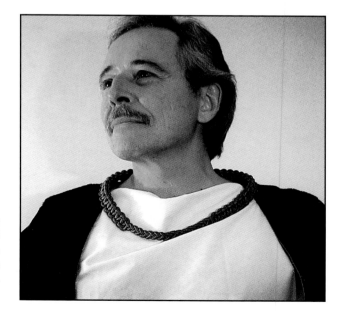

In creating each of these paintings,
I collect all of the components to be used,
sketch them
and then create what artists call
a thumbnail sketch
(see right).

Each separate drawing (opposite page)
is then shuffled about
to make a pleasing composition,
then transferred
onto the final art board to finish.

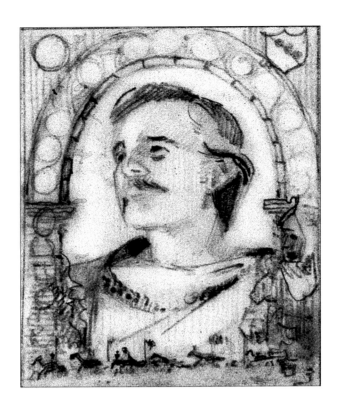

Portrait: MARCO POLO / "AGE OF DISCOVERY NAVIGATORS"
by Constance Del Vecchio/Maltese

LEGEND

The arch that creates his frame is the arch around the door to Marco Polo's home, which is standing in Venice. Polo's Coat of Arms is in the upper left corner. The background is an ancient map of Venice indicating the birthpace of Polo. At the lower left are Kublai Khan and a coin of King Hetum and Queen Isabel of Armenia Minor (Petite Hermanie). Along the bottom, Marco Polo and Kublai Khan lead Mongol soldiers in a victorious attack against the Moslems. Pope Gregory X is in the bottom right corner. Above him is the Moslem zealot Ben Youseff.

the chances and changes of human

Arms of the Ca' Polo.

THE STATE OF THE EAST AT

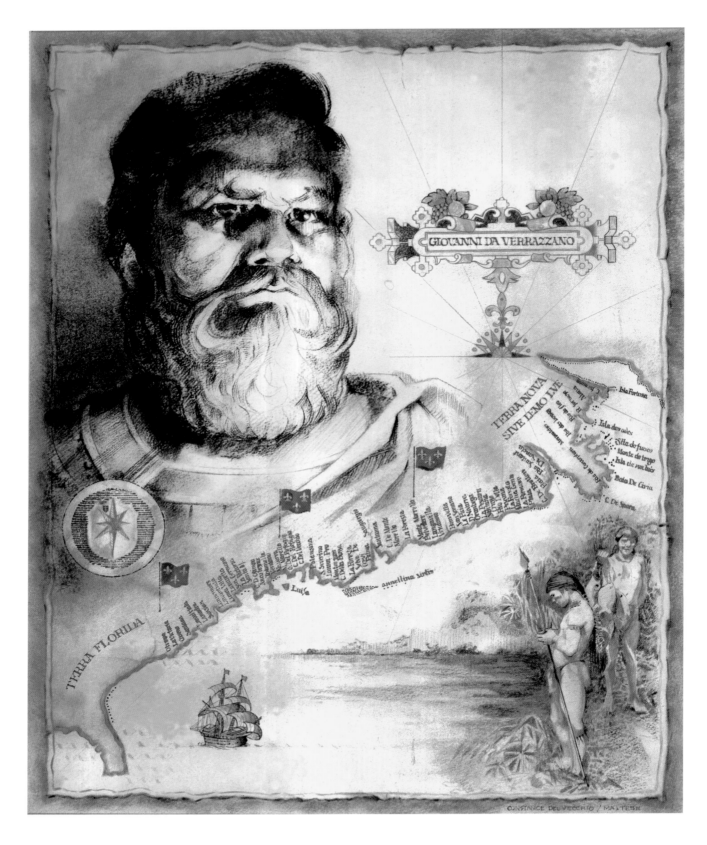

Looking every bit the "gentleman explorer," as he was termed, Giovanni sailed under the French banner in 1524 and claimed the coastline that includes New York harbor

JOSEPH G. GOLIA

I am a Justice of the Supreme Court of
New York now and was when I posed for the
portrait of Giovanni Da Verrazanno for
Constance. Before that I was a Judge of the
Civil Court of New York City.

I reside in Douglaston Manor, Queens with my
lovely wife, Rosalie, and have two wonderful
children.

I was born May 17, 1938, served in the United
States Army, honorably discharged in 1966,
admitted to practice law 1966, United States
District Court Southern District 1975, Eastern
District 1975, Supreme Court 1979, District of
Columbia 1981.

I was honored with a Presidential Citation by
President Jimmy Carter, was the recipient of
the United States Selective Service Medal
1978. I belong to many law and community
organizations, but I enjoy contributing my time
to church and athletic clubs such as St. Ann's
Roman Catholic Church, Queens County
Youth Development Corp., CYO basketball
coach, and Queensboro Hill Athletic League
baseball coach.

I received my law degree from New York Law
School and was on the Semi-Professional
Football League. Before I was appointed a
Judge I was an Assistant District Attorney and
Chief of the Youth Bureau. I have also served
in the capacity of Acting Chief of the Supreme
Court for the District Attorney's Office. I han-
dled more than two hundred Criminal Court
hearings and trials and a total of more than six
hundred Criminal Court dispositions.

GIOVANNI DA VERRAZZANO 5

It was in the Spring of 1989 that I found the perfect model for Verrazzano. Even though this was not in the chronological order of landfall (Verrazzano landed on our eastern shore in 1524), I had seen the face of Verrazzano in Supreme Court Justice Joseph Golia and pursued him in order to ask him to set aside some time for a sitting.

While he was delighted to be one of the discoverers, time was a problem. Time was something the Judge had little of, so we arranged for me to come by his chambers in the courthouse at lunch time.

So off I went with sketch pads, charcoal, flood lights, cameras and a large white bedsheet. (I used the sheet to drape over his shoulder to resemble the clothing of the time).

There was a security check as you enter the large, columned Queens courthouse. The officer asked to see what I was carrying, and while the sketching material and cameras were easy enough to explain, I got the strangest look when he came upon the bed linen. "It's supposed to look like a Roman Toga," I blurted out. "Oh, I see," he smiled, and waved his hand for me to pass. I understand Justice Golia became a great source of conversation after that exchange.

This was the only time that I superimposed a beard and mustache on a clean-shaven face. "The Gentleman Explorer," as Verrazzano was known, was shown in old portraits to have a magnificent growth of hair upon his face. The bone structure of the Judge's face seemed to duplicate that of the old portraits, so it seemed only natural that the Judge should have this beard. While it was difficult to imagine how the light would have fallen on the beard without actually seeing it, I referred to a plaster bust of the bearded Explorer and applied that to the face of Justice Golia. Since my purpose was to make these men come alive for today's audience, I felt the alliance of old with new was a successful one.

Why they called Giovanni the "Gentleman Explorer" I can't fathom, since he started his sailing career as a pirate. I don't believe piracy

Justice Joseph Golia as the "Gentleman Explorer" without his beard. ➡

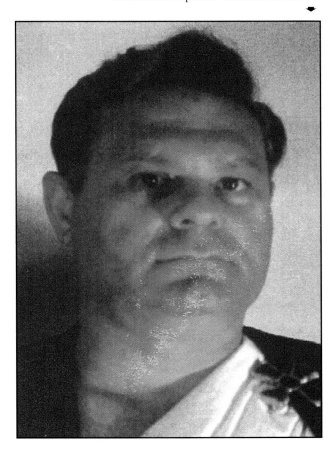

29

to be a gentlemanly occupation; however, his bearing and stature might have inspired the complimentary title. It was written that nothing gave him more pleasure than "relieving" a Spanish ship of her cargo and delivering it to France.

Verrazzano sailed under the French flag and on France's behalf claimed many a port on the eastern shore of the New World, starting on the north end and continuing south to Florida.

Giovanni sailed with his brother, the mapmaker Hieronimus Da Verrazzano. The map duplicated in Verrazzano's portrait has handwritten towns and city names, some of which remain the same today. I could not resist the temptation to inject my own name next to C. del refugio (C. del vecchio).

Portrait: GIOVANNI DA VERRAZZANO / "AGE OF DISCOVERY NAVIGATORS"
by Constance Del Vecchio/Maltese

LEGEND

The surroundiing border is a depiction of an original map of Giovanni's brother, Hieronimus Da Verrazzano. The cities along the coastline are named after people familiar to captain and crew. The *Fleur De Lis* banner is the French flag. The circle with the eight-pointed star is Da Verrazzano's Coat of Arms. Below, off the coast of Florida, is his ship, "La Dauphine." Bottom right depicts Indians who were, for the most part, friendly. Unfortunately, during Da Verrazzano's second voyage to the New World, one tribe that he encountered was not friendly and killed and ate Giovanni in full view of his brother, who was powerless to help him.

⬥ Left to right: Nieves V. Garchitorena, Gail Giordano and
Constance D. Maltese at the "Age of Discovery" exhibition
in the Queens Borough Library on November 13, 1991.

As it appeared in the *New
York Times* in 1992,
Justice Joseph Golia
as he posed for
Giovanni Da Verrazzano.

Justice Joseph G.
Golia, above, was
the model for the il-
lustration of Gio-
vanni da Verraza-
no, right.

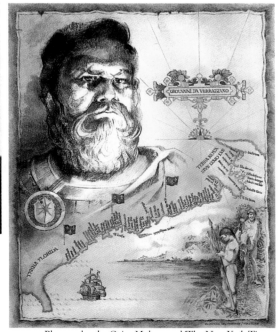

Photograhps by Ozier Muhammad/The New York Times

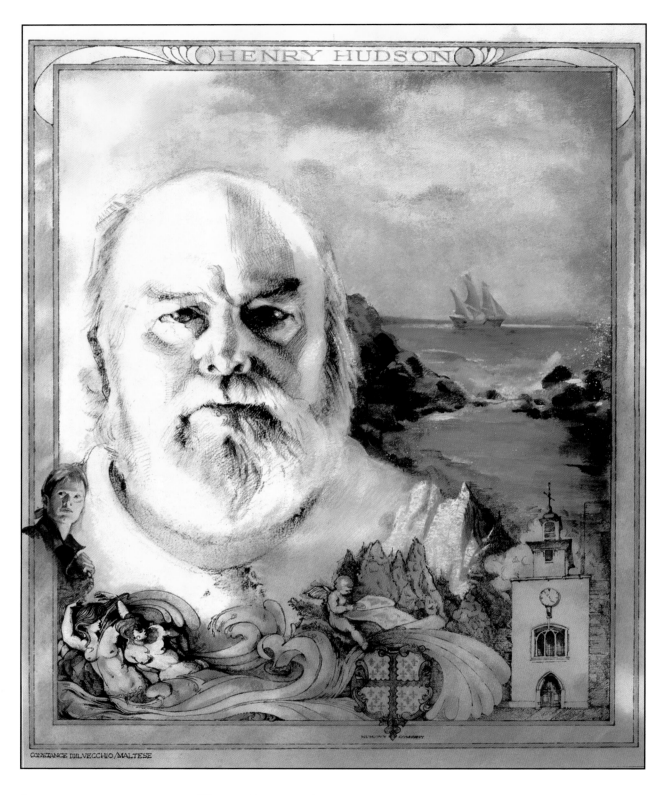

HENRY HUDSON

CONSTANCE DELVECCHIO/MALTESE

LITTLE IS KNOWN ABOUT HENRY HUDSON'S EARLY LIFE AND FAMILY, BUT RECORDS REVEAL THAT HE WAS MASTER OF A SMALL VESSEL IN THE SERVICE OF THE MUSCOVY COMPANY WHEN HE FORMULATED PLANS FOR ARCTIC EXPLORATION. HE LIVED IN LONDON WITH HIS WIFE, KATHERINE. THEY HAD THREE SONS — OLIVER, JOHN AND RICHARD. JOHN, HIS VOYAGE COMPANION, WENT WITH HIM TO HIS MARTYRDOM

RON BAUMANN

I was born May 5, 1937 in Greenville, New York, the eldest son of Wilbur and Thelma (Boomhower) Baumann. My brother Thomas and I were both educated in the Greenville School system. I decided to follow in my father and grandfather's footsteps by operating the family business, Baumann's Contractors, Inc. on Main Street in Greenville. We do plumbing and electrical contracting as well as run a retail store and deliver LP gas for cooking and hot water.

My loving wife Edie and I have four children and ten wonderful grandchildren. I love to relax by riding my Harley Davidson motorcycle through the Catskill Mountains. In the winter you can find me riding my snowmobile. I'm the happiest with a little snow on my whiskers. Camping, hunting and fishing are also high on my priority list.

I'm looking forward to my retirement in the near future and enjoying my toys and tinkering with repairing antique clocks, and of course enjoying my grandchildren.

I served in the Naval Reserve for twenty-four years and retired as a Chief Petty Officer. I'm also a life member of the Greenville Volunteer Fire Company and past Fire Chief. For six years I was a part-time Fire Instructor for New York State.

RON BAUMANN

I was born on May 5, 1937 in Greenville, New York, the eldest son of Wilbur and Thelma (Boomhower) Baumann. My brother Thomas and I were both educated in the Greenville School system. I decided to follow in my father and grandfather's footsteps by operating the family business, Baumann's Contractors, Inc. on Main Street in Greenville. We do plumbing and electrical contracting as well as run a retail store and deliver LP gas for cooking and hot water.

My loving wife Edie and I have four children and ten wonderful grandchildren. I love to relax by riding my Harley Davidson motorcycle through the Catskill Mountains. In the winter you can find me riding my snowmobile. I'm the happiest with a little snow on my whiskers. Camping, hunting and fishing are also high on my priority list.

I'm looking forward to my retirement in the near future and enjoying my toys and tinkering with repairing antique clocks, and of course enjoying my grandchildren.

I served in the Naval Reserve for twenty-four years and retired as a Chief Petty Officer. I'm also a life member of the Greenville Volunteer Fire Company and past Fire Chief. For six years I was a part-time Fire Instructor for New York State.

HENRY HUDSON

It was June of 1990 and Mom and I were spending time at our summer place in upstate New York. We have a home on a small lake where no matter how warm the days may become, the evenings are beautifully cool and one can snuggle under a down comforter for the night. Mom and Dad started this summer haven in the fifties with just a room and a half. Every year since then it has grown and is now what we refer to as a Lake House. I continued this tradition of building on the house by adding an airy studio with north light and a skylight.

I was putting the last touches on the Verrazzano painting as Mom began preparing the Apple "Kuchen" for that evening's dessert. She always made a yeast dough and spread the dough on a large cookie sheet, filling half with apples and half with crumbs only because Serphin, my husband, doesn't like apples. (Mom always said she wanted to make Mother–in-law of the Year.) As she proceeded to add some water to the dough, the water pipe on the sink started leaking furiously. We bandaged the pipe and simultaneously reached for the phone and called the plumber. Baumann Contracting had helped Mom and Dad in the very beginning with the building of our little paradise, so it was only natural for us to yell for their help now.

Within the half-hour, help arrived. It wasn't Baumann Senior who came but son Ron. Hearing the revving of a loud motor, I glanced out the window and saw Ron looking very much like a Hell's Angel disembarking a Harley, removing a box of tools, and coming to our door. I felt a little easier about opening the door since I have a large dog with a very short fuse. We showed Ron our problem and it was very quickly clear that Ron is not what he had appeared to be, but is a very soft-spoken, efficient plumber.

As we were explaining our problem with the sink, Mom popped her Kuchen into the oven and asked Ron if he'd take a look at the pilot light in the stove, as it wasn't working properly.

While Ron was adjusting the pilot light, he asked about the painting that I was doing. I told him about the Quincentenary Series and that Verrazzano was the one I was finishing. While talking to him, I had a book open to a page that had a likeness of Henry Hudson. It was an etching of the elder Hudson and his son John being put into a life boat after being ejected by a mutinous crew. "My God," I said, "You look just like Henry Hudson! I'm just finishing Verrazzano and I'll be starting the Hudson painting soon. How would you like to pose for me?"

He answered, "What do you want me to do first — fix your sink or pose?" Since the sink was having a tizzy fit, the answer was obvious. The sink was repaired, the Kuchen

The ever-elusive Hudson Arms finally turned up at the New York Historical Society.

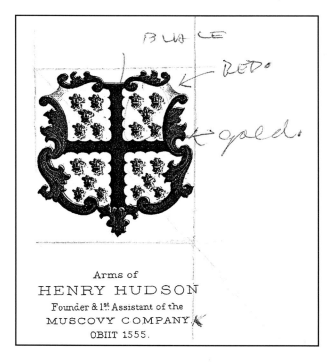

Arms of
HENRY HUDSON
Founder & 1st Assistant of the
MUSCOVY COMPANY
OBIIT 1555.

was delicious and Ron promised to come back the following week to sit.

He removed his headband and, after I replaced his tee shirt with the proper attire of the time, Henry Hudson was reborn. The beard, the mustache and the shape of the head were amazingly similar to the etching I had seen, and there was no doubt in my mind that creating the image of the old navigator would be no problem.

This was to be the easiest part of the Hudson painting. Since I had predetermined that I would include the Coat of Arms of each navigator, I now proceeded to search for Hudson's. Not so easy — I pored over the reference books and picture library as well. There was relatively little known about Hudson other than that the Hudson family was master of a small vessel in the service of the Muscovy Company. Henry lived in London with his wife, Katherine, and their three sons – Oliver, John (the son depicted in the painting), and Richard.

Remembering the Hudson Museum, I thought who better to have his Coat of Arms? — so I phoned them. A young lady very courteously answered and I told her of my plight, to which she answered, "Oh, the Museum is named after the Hudson River!" No help here!

My port of last resort was going to be the New York Historical Society. It was now a month and a half after my first inquiry. I was putting in place all the other points of information in the composition and creating a pleasing image of Hudson, plus his ship the Half Moon, coming into the Bay, the two mermaids Hudson claimed to have seen (so noted in his log), and his son John. I left a spot where the Coat of Arms would be, but hope for finding one was dimming. The Society told me they had nothing readily available but if I filled out a formal request they would look into it and get back to me if anything turned up.

I went home a little discouraged, but two days later I received a call saying that if I was satisfied with the Coat of Arms that the Moscovy Company gave him, they would send it to me. Finally it was done. I could now put the last item in my painting and it was complete.

Portrait: HENRY HUDSON / "AGE OF DISCOVERY NAVIGATORS"
by Constance Del Vecchio/Maltese

LEGEND

Superimposed on the left border is Hudson's son John – a boy of eleven on his first voyage (1607). The bottom left depicts the sighting of two mermaids, according to his journal. At center, Serafim gives blessing to charts of Hudson, pictured above the Coat of Arms. In the center background are ice-tipped mountains of Newfoundland. At lower right is Saint Ethelburga's church in Bishopsgate, London, where Hudson and crew went for blessing. The upper right background shows Hudson's ship, Half Moon, moving into Hudson Bay.

◆ Ron Baumann stands next to portrait of Henry Hudson at the
Italian-American Legislators' Exhibit in Albany with Constance looking on.

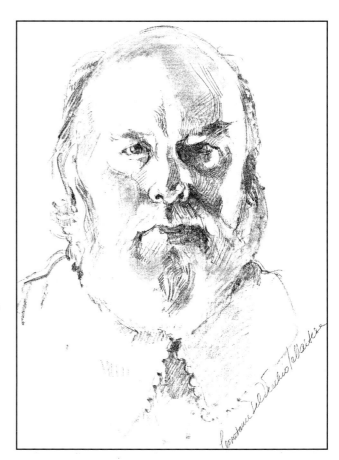

First pencil sketch of
Ron Baumann.
Often several sketches
had to be made
to acquire
the desired effect.

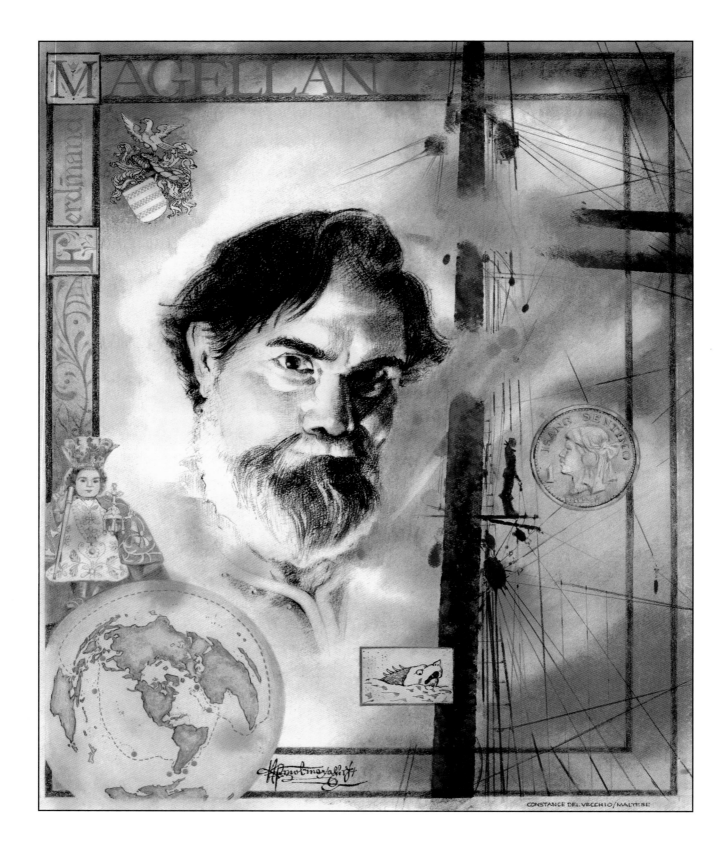

A MAN DARING TO FORGE INTO THE UNKNOWN, TO BE THE FIRST EXPLORER TO
CIRCUMNAVIGATE THE GLOBE AND PROVE THE WORLD IS ROUND

FRANK D'ORAZI

I was born in 1927, a native of New York. I served with the Field Artillery, U.S. Army from 1944-1946 and graduated with a B.A. degree from St. John's University in 1950. My lovely wife Alice and I were married in 1952 and raised six children and enjoy eleven grandchildren.

I am a co-owner of Cordon Bleu Caterers and the Fleur di Lis Caterers in Queens County, New York. I am president of the Greater Woodhaven Development Corporation, and a member of the Board of Directors of the New York State Restaurant Association, the Board of Managers of 12 Towns, the YMCA, the Advisory Board of Queens Lighthouse for the Blind, and the Knights of Columbus, and I served six years on Community Board 9.

I have been very active in Kiwanis and enjoy contributing my time and efforts to promoting the welfare of our youth organizations. A member of Woodhaven Kiwanis Club since 1979, I was President in 1981-82, President with Honors in 1982-83, and Chairperson of the Board of Directors in 1987-91. In 1984-85 I was Lieutenant Governor of Queens West Kiwanis, and from 1986 to 1989 served as District Chairman of South Area International President's Visit. I have been District Chairperson of the Hugh O'Brien Youth Foundation and Vice President of the District Foundation.

In 1991 I was invested into the Equestrian Order of the Holy Sepulchure of Jerusalem with the rank of Knight Commander.

I was honored in 1993 by the Italian American Professional and Business Men's Association, and was named Restauranteur of the Year in 1994 by the New York State Restaurant Association.

FRANK D'ORAZI

I was born in 1927, a native of New York. I served with the Field Artillery, U.S. Army from 1944-1946 and graduated with a B.A. degree from St. John's University in 1950. My lovely wife Alice and I were married in 1952 and raised six children and enjoy eleven grandchildren.

I am a co-owner of Cordon Bleu Caterers and the Fleur di Lis Caterers in Queens County, New York. I am president of the Greater Woodhaven Development Corporation, and a member of the Board of Directors of the New York State Restaurant Association, the Board of Managers of 12 Towns, the YMCA, the Advisory Board of Queens Lighthouse for the Blind, and the Knights of Columbus, and I served six years on Community Board 9.

I have been very active in Kiwanis and enjoy contributing my time and efforts to promoting the welfare of our youth organizations. A member of Woodhaven Kiwanis Club since 1979, I was President in 1981-82, President with Honors in 1982-83, and Chairperson of the Board of Directors in 1987-91. In 1984-85 I was Lieutenant Governor of Queens West Kiwanis, and from 1986 to 1989 served as District Chairman of South Area International President's Visit. I have been District Chairperson of the Hugh O'Brien Youth Foundation and Vice President of the District Foundation.

In 1991 I was invested into the Equestrian Order of the Holy Sepulchre of Jerusalem with the rank of Knight Commander.

I was honored in 1993 by the Italian American Professional and Business Men's Association, and was named Restaurateur of the Year in 1994 by the New York State Restaurant Association.

FERDINAND MAGELLAN

It was now August 1990. After completing Henry Hudson, I was now on a quest to find a model for the ruthless and bold Ferdinand Magellan. Searching through the picture library files for old images of the courageous navigator, I came upon a copy of a painting (artist unknown) with piercing eyes and a bushy mustache and beard. This would be my guide for the model.

I wouldn't have long to wait. Serphin was having a fund-raiser at Cordon Bleu. Frank D'Orazi, proprietor of the Cordon Bleu and Fleur de Lis catering halls, came to oversee the arrangements. He wanted everything to be done properly, and while he was discussing the details of the food and wine with Serphin, I noted an amazing similarity to Magellan's piercing eyes. Yes, Frank wears glasses and

"...no other had so much natural wit boldness, or knowledge...,"
wrote Antonio Pigafetta, commissioned by the Pope to accompany Ferdinand Magellan and keep the log of his circumnavigation of the globe in 1522.

has this terrific handlebar mustache, which I later had to eliminate, but nonetheless the resemblance was very apparent.

Since I really didn't know Frank very well, I felt I couldn't just walk up to him and ask him to pose for me. This is where I again used my husband. "Please, Serf," I began. "Let's ask Frank to lunch so I can get to know him better and ask him to put two hours of his valuable time aside for me and . . ."

"Okay, okay," he waved his hand. "I'll call him. But we'll take him to Ellio's so he

doesn't feel he has to cater the lunch as well."

We picked Frank up at Fleur de Lis and drove down Myrtle Avenue to Ellio's. During lunch I told Frank about the Quincentenary and the deadline of my mission to complete a series of navigators — in which Magellan was prominent. He removed his glasses and rubbed his eyes in deep thought. (Those eyes, oh YES!) I think the clincher was when I presented him with a framed print of the "Young Visionary."

At last Magellan was mine. I arranged for a shoot at the Fleur de Lis. Bringing my usual props (sheet, jewelry, cameras, lights, etc.), I was escorted to an unused catering room so that we would have privacy.

Frank entered the room, assuring me that

Portrait of Magellan, artist unknown,
➠ from Museo de Arte Moderno, Madrid (Spain).

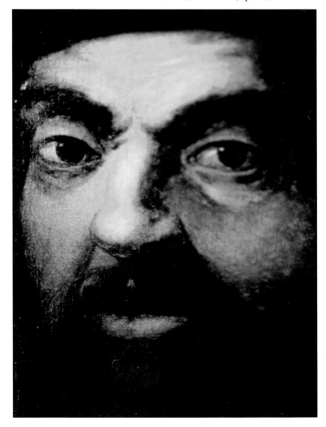

we could take all the time we needed, as the room wasn't booked until evening.

"Fine," I said. "Then would you mind removing your shirt, undershirt and glasses? We'll just drape the sheet over your shoulder (a la toga) and muss your hair a little. To make you look ruthless," I added.

To further explain *ruthless*, I told Frank of Magellan's slitting of a captain's throat on the mere suspicion of mutiny by the captain.

"Okay, Frank, give me ruthless." He glared at me with those magnificent eyes and I proceeded to take a full roll of thirty-six photos, changing the lighting with slight variations on that theme.

Now this is something that we had agreed would be "our secret," since I really goofed. I opened up the camera to re-load and discovered that I had forgotten to load the film! Good Lord, I'm trying to look cool and now I have to break it to him that I need to do this all over again. But, unlike Magellan, Frank was a true gentleman and smiled while hold-ing back his amusement.

Quickly recouping, I now loaded the camera and re-did what we had done before — except now Frank was really getting into the swing of it and gave me a *ruthless* glare that would stop a heart beat!

Then we heard a door open behind us. A workman was coming in to start preparations for the evening when he saw Frank standing in a sheet, glaring at me as if to kill! I made some feeble attempt to explain this somewhat outrageous scene, but before I could finish he backed out of the room, obviously very embarrassed, saying how sorry he was to interrupt us. Both Frank and I had a good laugh over that one!

I'm including pictures of both the early painting of Magellan and the preliminary sketch of Frank with his handlebar mustache. I removed the handlebar and replaced it with a bushy mustache for the final painting. In both pictures you'll see the same eyes. THOSE EYES.

Portrait: FERDINAND MAGELLAN / "AGE OF DISCOVERY NAVIGATORS"
by Constance Del Vecchio/Maltese

LEGEND

The frame is from Antonio Pigafetta's log of Magellan's journey. At the upper left is Magellan's Coat of Arms. At right are the mast and rigging of the ship — with "St. Elmo's Fire," an electrical phenomenon that occurs at the equinoctial line as a storm appears. The coin overlapping the rigging glorifies "Lapulapu," the Philippine native who resisted European seamen and slew Magellan. An old print of a shark appears near the base of the mast. Magellan's signature is in the frame at the bottom, alongside a globe depicting his famous voyage (1519–1522). Above it is a still existing wooden statue of the Christ Child, given to the Princess of Cebu in 1520.

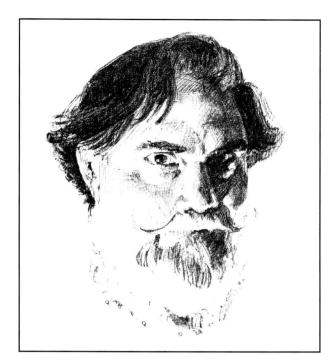

The first sketch of
Frank with his
wonderful
handlebar mustache.
Unfortunately,
it had to go.

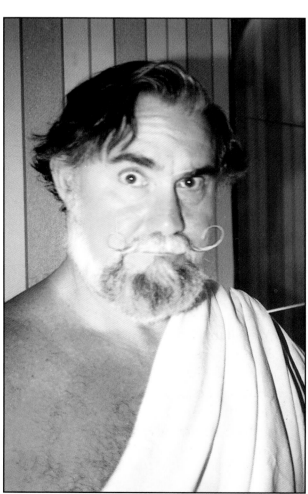

Mr. Frank D'Orazi
posing in a sheet
a la toga
in the catering hall
Fleur de Lis.

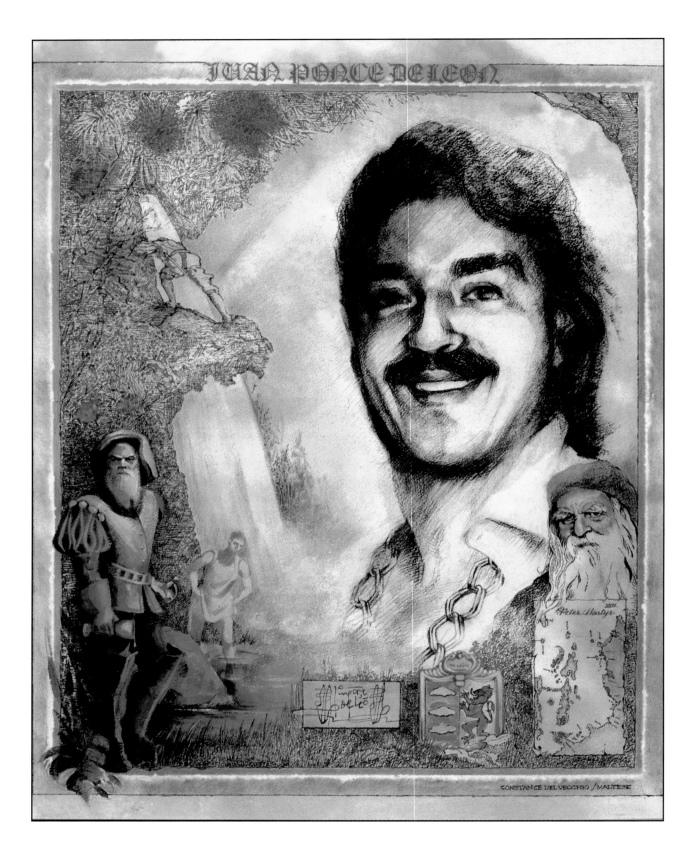

OF NOBLE BIRTH, PONCE DE LEON WAS THE FIRST PUERTO RICAN HOMESTEADER AND WENT ON TO DISCOVER FLORIDA ON APRIL 2, 1513. BECAUSE OF HIS SEARCH FOR THE FOUNTAIN OF YOUTH, HE WAS SOMETIMES CALLED THE FIRST DON QUIXOTE

SALVATORE CRIFASI

I was born in 1955 in the Bushwick section of Brooklyn, New York. My parents, Jack and Maria Crifasi, emigrated from Italy in 1954. I didn't speak English until I was four years old.

I graduated from St. Joseph Elementary School in 1969. We then moved to Queens, where I attended Newtown High School and graduated in 1973, then went to Queensborough Community College. I obtained my New York State license as a Real Estate Salesperson and simultaneously worked evenings as a parcel sorter at United Parcel Service. After six months I became a supervisor and within a year a manager.

In 1979 I opened my own real estate firm, Crifasi Real Estate, Inc., in Ridgewood, Queens — while still working as night manager at UPS in Manhattan. It wasn't long (1981) before I also opened an office in Middle Village — now my main office — and resigned from UPS.

I have been instrumental in many commercial real estate transactions in Middle Village. For example, I placed the Middle Village Library, the headquarters for Cross County Federal Savings, the first community medical facility of New York Hospital of Queens/ Wyckoff Heights, and, in Glendale, the main office of School District 24.

I have been active with many business and community organizations — president of the Queens Real Estate Board and of the Long Island Board of Realtors Western Queens Chapter, and board member of the Queens Council of the Arts, West Maspeth Industrial Development, Ridgewood Local Development, Forest Park Trust, and Multiple Listing Service of Long Island.

I married my life partner Catherine in 1979 and have three great children. Marissa, who attended Rensselaer Institute, Sal Joseph, and Richard — both attending Holy Trinity High School.

I love to golf, play softball and go surf fishing.

SALVATORE CRIFASI

I was born in 1955 in the Bushwick section of Brooklyn, New York. My parents, Jack and Maria Crifasi, emigrated from Italy in 1954. I didn't speak English until I was four years old.

I graduated from St. Joseph Elementary School in 1969. We then moved to Queens, where I attended Newtown High School and graduated in 1973, then went to Queensborough Community College. I obtained my New York State license as a Real Estate Salesperson and simultaneously worked evenings as a parcel sorter at United Parcel Service. After six months I became a supervisor and within a year a manager.

In 1979 I opened my own real estate firm, Crifasi Real Estate, Inc., in Ridgewood, Queens — while still working as night manager at UPS in Manhattan. It wasn't long before I also opened an office in Middle Village — (1981) and resigned from UPS — now my main office.

I have been instrumental in many commercial real estate transactions in Middle Village. For example, I placed the Middle Village Library, the headquarters for Cross County Federal Savings, the first community medical facility of New York Hospital of Queens/Wyckoff Heights, and, in Glendale, the main office of School District 24.

I have been active with many business and community organizations — president of the Queens Real Estate Board and of the Long Island Board of Realtors Western Queens Chapter, and board member of the Queens Council of the Arts, West Maspeth Industrial Development, Ridgewood Local Development, Forest Park Trust, and Multiple Listing Service of Long Island.

I married my life partner Catherine in 1979 and have three great children, Marissa, who attended Rensselaer Institute, Sal Joseph, and Richard — both attending Holy Trinity High School.

I love to golf, play softball and go surf fishing.

JUAN PONCE DE LEON 8

Reading about Ponce De Leon brought to mind the swashbucklers of yore, in particular Errol Flynn of movie fame. Since Ponce De Leon's ancestors were of noble birth, he had need of little, and easily became the first Governor of Puerto Rico, then known as Boraquiene.

Because of his background, Ponce De Leon was educated in the art of swordsmanship and was well-read in all subjects, including the science of agriculture. The production of yucca and yams stood him in good stead and he passed this knowledge on to the people of Boraquiene. He was known to have more food provisions on his ships than many other captains, making traveling with him more desirable. Ponce De Leon enjoyed his lot in life.

It was late September. Countdown '92 was fast approaching. I had completed Magellan and barely had time to rest on my laurels. Time to seek a model once again. I have to tell you, it's a pleasurable task. To date all my models had been interesting to converse with and look at.

Ponce De Leon was no exception. Friends were holding a dinner for Serf's re-election at a great favorite restaurant, Tony Seminerio's and Tony Modica's La Bella Vita — and lo and behold, who caught my eye there was swashbuckler Sal Crifasi. I wasted no time zeroing in on him and asking him to honor me by bringing Juan Ponce De Leon to life!

Sal Crifasi is president of Crifasi Realty in Queens, and while his knowledge of agriculture might be limited, his being adept in the swordplay of realty gives him a leg up.

I tried to fill him in on the series, and since the Maspeth Town Hall was having an exhibit of the paintings already completed, I suggested Sal attend the exhibit in October to commemorate Columbus Day.

Sal and his wife, Catherine, did attend the exhibit. I then won him over and scheduled a shooting session at his office in Middle Village. I didn't ask him to take off his shirt, only to open the buttons to show his chest and chain with the Maltese Cross.

He already had long hair, so that it was not necessary to add a thing. The first picture (I take at least 72 shots to make sure) turned out to be the best in the lot .

Juan Ponce De Leon is the only painting that depicts two versions of the same man. At the lower left you will notice that the older Ponce De Leon stands holding a goblet that he has just taken a drink from. He is hoping against hope that it will make him young again as he searches in Florida for the Fountain of Youth. Unfortunately, it proved to be not the desired Fountain but yet another failure.

☛ Working sketch of the Ponce De Leon coat of arms with the signature of Juan Ponce De Leon as it appeared on a letter to Emperor Charles V.

Peter Martyr was the first to chart a map that would show the most likely location of the Fountain of Youth, and although they exhausted the area, no such fountain was found (although there are many spas in Florida and Puerto Rico that claim that benefit!).

Later in November '91, after Ponce De Leon was completed, I was able to make a presentation of one of the prints of Juan Ponce De Leon. It was on a legislative trip to Puerto Rico that we met with Vice President Antonao Colorado, and I was honored to make the presentation to him. I was further honored by being made an honorary Puerto Rican. The Puerto Rican Hispanic Task Force sponsored the trip, and I must say Ponce De Leon would be proud. It was one of the nicest experiences I've ever had.

Juan Ponce De Leon's handsome face would later be one of four navigators chosen to be on commemorative plates. Since they were sold primarily in Florida, Ponce De Leon soon became a rarity. (The Fountain of Youth thing again).

Portrait: JUAN PONCE DE LEON / "AGE OF DISCOVERY NAVIGATORS"
by Constance Del Vecchio /Maltese

LEGEND

At upper left is one of his crew dipping into what might be the Fountain of Youth. On the lower left is an older Juan Ponce De Leon in his quest for the fountain, as a crew member wades in the water. Below is the signature of Ponce De Leon and his Coat of Arms. On the lower right is Peter Martyr's map of 1511 with the mapmaker directly above it. Ponce De Leon perished in 1521 — the result of a Carib's poisoned arrow.

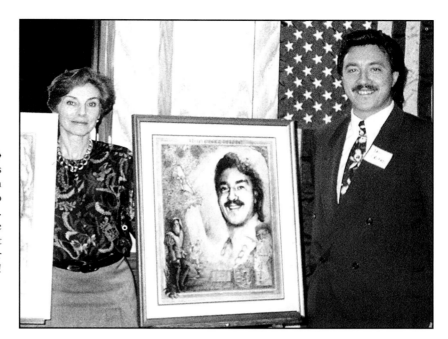

Constance unveils Juan Ponce De Leon at presentation to the model, Sal Crifasi. Sal displays that same winning smile that made him the popular swashbuckler!

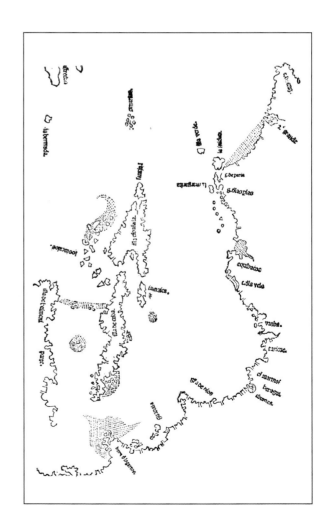

Peter Martyr map of 1511, from Winsor, Justin. "Narrative and Critical History of America." Boston: Houghton, Mifflin & Co., C1886. Vol. II, p. 110.

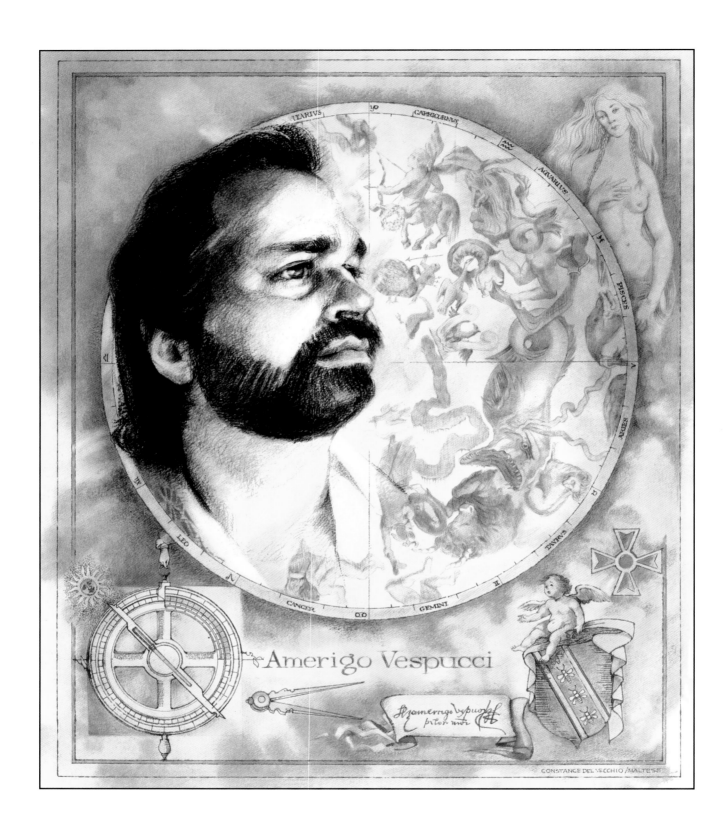

Amerigo Vespucci

VESPUCCI WAS A SUCCESSFUL MERCHANT FASCINATED BY ASTRONOMY AND CARTOGRAPHY. HIS STUDY OF AMERICA'S COASTLINE DURING HIS VOYAGES (1479-1503) PROVIDED THE FIRST CLUES THAT THIS WAS A NEW CONTINENT AND NOT THE INDIES. MAPMAKER WALDESMULLER CALLED THE NEW LAND "AMERIGO"

RICHARD "BO" DIETL

As a proud native New Yorker, it seemed natural that I could do the most good as a provider of law and order. I became a New York City police officer and detective and served from June 1969 until I retired in 1985. With several thousand arrests to my credit, I am one of the most highly decorated detectives in the history of NYPD. I was instrumental in the arrest and conviction of the suspects in two highly publicized cases; one concerned a 31-year-old nun who was raped and tortured in an East Harlem convent in 1981 (27 crosses were carved into her), and the Palm Sunday Massacre in 1984, in which eight children and two women were found shot in their apartment.

In 1986 I was the Republican and Conservative candidate for the 6th Congressional seat in New York, and in 1989 President Bush appointed me Co-Chair of the National Crime Commission. Six years later Governor Pataki named me Chair of the NYS Security Advisory Committee. I was Security Consultant to the 1992 and 1996 National Republican Conventions.

During this same period I became founder, chairman and CEO of Beau Dietl and Associates. I counsel clients with respect to corporate and financial fraud investigations, international assets searches and analysis, risk management services, due diligence, mergers and acquisitions. We serve worldwide. It was during this time that Constance came to my Maspeth office and asked me to pose for Amerigo Vespucci. As she said, I may not be an angel, but my face was angelic.

Throughout the years I've actively endorsed and supported many charitable organizations including C.O.R.E. (Congress of Racial Equality), NYC Police & Fireman Widows and Children, SIDS, Tomorrow's Children Fund, Juvenile Diabetes Foundation, Mothers' Voices, Sloan Kettering Cancer Center, and the National Center for Missing and Exploited Children.

I co-authored and was executive producer of the made-for-TV-movie "The Grey Area," which depicted a tale from my private investigator experience. I also co-authored "One Tough Cop," about my life in the NYPD, which later became a movie starring Stephen Baldwin. Joining the computer world, I developed software, "Bo Dietl's One Tough Computer COP," designed for parents to monitor their children on the Internet, protecting them from sexual predators who routinely surf the Net.

AMERIGO VESPUCCI 9

Even though I was still finishing Ponce De Leon (I was duplicating an antique print , a drawing of the Fountain of Youth, which required a line by line to make it look like an etching; a friend said by the time I finished, it would *be* antique), I started to research Amerigo Vespucci.

The third of four sons, Amerigo Vespucci was born in Florence on March 18, 1454 into a leading upper-class family that included an ambassador, a bishop, and a banker — all friends of the powerful Medici family.

Amerigo had to cross Florence twice daily to attend a private school at the Convent of San Marco, conducted by his uncle, Father Georgio Antonio Vespucci.

After twenty years of service in Florence, Amerigo was sent to Seville as a merchant. He became interested not only in shipping but also in mapmaking and utilized his knowledge of celestial markings to create his maps.

His cousin Simonetta Vespucci was the model for Botticelli's "Birth of Venus." Amerigo himself was portrayed as a young lad in Domenico Ghirlanaio's painting of the Vespucci family. His face had a cherubic quality, with large eyes and rather full lips. It was with this painting that I began my search for my Amerigo. All I had to do was to find someone who had the face of an angel, yet looked as though he would be a shrewd merchant and a visionary.

In December of 1990 I started to piece together what could be a good background for the Vespucci painting. I was leaving a spot empty for my Amerigo Vespucci, but now I had to really zero in on it. An interesting note on the Coat of Arms was that Vespa means bee, which is why the Vespucci Coat of Arms has three bees going across it diagonally.

January 2, 1991. My dog, Copper, went to the front door to retrieve the newspaper, which he did every morning. Recovering from a lovely New Year's evening, I reached for my coffee and newspaper almost simultaneously.

Bo Dietl, a good friend and famed as the most decorated policeman in New York State, was pictured in the newspaper being interviewed by the press as he spoke of his security business located in Maspeth. His face — cherubic, large dark eyes, full lips — and a beard, mustache and longish hair. Perfect!

Again Serf to the rescue! Yes, he would call and ask Bo Dietl if he would sit for me.

Luckily his office was no more than a mile from my home. I was able to firm up the

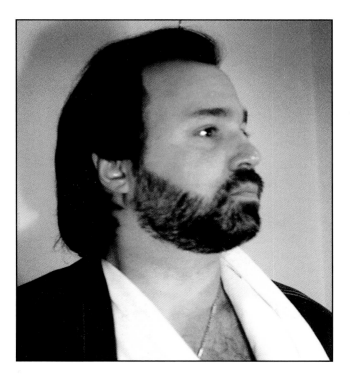

◀ The famous detective Richard "Bo" Dietl posing for the great navigator, Amerigo Vespucci — January 16, 1991.

sitting for January 16. When I arrived at his office, there was a great deal of activity with people milling about and secretaries calling out to Bo to pick up one line then another. He indicated to me that I would have to hurry. His mother was in his car waiting for him to drive her to the hospital for treatment of her infected foot. Talk about stress . . .

I said that maybe another time would be better. "No, no," he said. "Mom will be alright. JUST HURRY." So I hurried. At least by now, setting up lights and cameras had become second nature, and, quite frankly, he was the perfect ham! We were done in record time and, imagining his mother having gangrene set in, I scooted him out the door.

I give all the models in the series one free print. When I gave Bo his print, he remarked how much he enjoyed the painting — especially since he had that nice naked lady in the corner (Birth of Venus).

I have seen Bo many times since then and he never misses the opportunity to tell me how much he enjoyed being in the series. I, of course, can only say that I enjoyed it as well. Some of you may recall having seen the movie about Bo Dietl and his amazing career. Like Amerigo, he has the face of an angel, the cunning of a shrewd businessman, and the courage of a visionary.

Portrait: AMERIGO VESPUCCI / "AGE OF DISCOVERY NAVIGATORS"
by Constance Del Vecchio/Maltese

LEGEND

The upper right and center background displays a southern celestial map. Below, from left to right are an astrolabe, divider, signature, Coat of Arms, Maltese Cross from "Knights of Malta" (founded by Amerigo's younger brother, Gurilamo). In the upper right is Botticelli's "Birth of Venus." Simonetta, the wife of Vespucci's cousin Marco, was Botticelli's model.

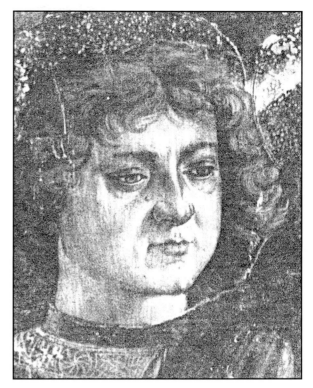

Portrait of Amerigo Vespucci
by Ghirlianaio.*
This and other portraits by Botticelli,
all featuring the 'angelic' quality
of the face, lead me to seek out
the large eyes and full lips.

Amerigo and The New World by
German Arciniegas

Proudly displaying his image
as the explorer, Bo Dietl accepts
his painting at the presentation.

47

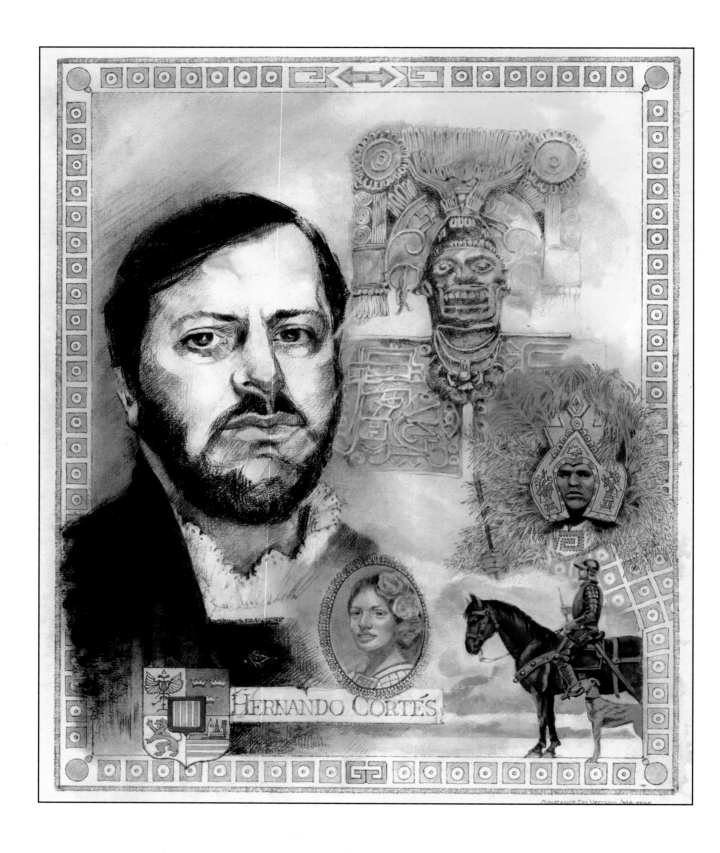

HERNANDO CORTÉS

A DETERMINED CORTES FORGED THROUGH COUNTLESS MILES OF ROUGH TERRAIN TO
CHALLENGE THE GREAT AZTEC LEADER MONTEZUMA. WITH THE ASSISTANCE OF HIS
INTERPRETER, MALINALLI, HE AND HIS MEN BECAME AN UNBEATABLE FORCE

THOMAS F. CATAPANO

I was born on August 16, 1949 in Brooklyn, New York, and continue to reside in Brooklyn. I received an A.A. in Political Science from St. John's University and hold a B.A. in American Studies, which I acquired while attending State University of New York, College at Old Westbury in Westbury, Long Island.

I was an Assemblyman representing the 54th Assembly District, which covers a portion of Bushwick, East New York, and Cypress Hills in Brooklyn, Kings County, when I posed for Constance as Hernando Cortes.

I was elected to the New York State Assembly in the General Election of 1982. I served as Chairman of the Assembly's Ethics and Guidance Committee, as a member of Aging; Banks; Governmental Employees; Consumer Affairs; Housing and Social Services Committees; and chaired the sub-committees on Housing for the Elderly and Volunteer Ambulance Services. I was also Chairman of the Assembly Task Force on New Americans and served on the Council of State Governments' Eastern Regional Conference Task Force on the Environment.

I was formerly the Director of Regional Services for the New York State Assembly House Operations Committee. I was also a Learning Consultant at St. Rita's Roman Catholic Church School in Brooklyn, New York. I am a member of the Kiwanis Club and a former member of the New York State Democratic Committee.

I am presently the Executive Director of the New York Conference of Italian American State Legislators.

THOMAS F. CATAPANO

I was born on August 16, 1949 in Brooklyn, New York, and continue to reside in Brooklyn. I received an A.A. in Political Science from St. John's University and hold a B.A. in American Studies, which I acquired while attending State University of New York, College at Old Westbury in Westbury, Long Island.

I was an Assemblyman representing the 54th Assembly District, which covers a portion of Bushwick, East New York, and Cypress Hills in Brooklyn, Kings County, when I posed for Constance as Hernando Cortes.

I was elected to the New York State Assembly in the General Election of 1982. I served as Chairman of the Assembly's Ethics and Guidance Committee, as a member of Aging; Banks; Governmental Employees; Consumer Affairs; Housing and Social Services Committees; and chaired the sub-committees on Housing for the Elderly and Volunteer Ambulance Services. I was also Chairman of the Assembly Task Force on New Americans and served on the Council of State Governments', Eastern Regional Conference Task Force on the Environment.

I was formerly the Director of Regional Services for the New York State Assembly House Operations Committee. I was also a Learning Consultant at St. Rita's Roman Catholic Church School in Brooklyn, New York. I am a member of the Kiwanis Club and a former member of the New York State Democratic Committee.

I am presently the Executive Director of the New York Conference of Italian American State Legislators.

HERNANDO CORTES 10

While it was true that the *Conquistador* and Explorer of Mexico was tough and perhaps ruthless, it is also true that to overcome the countless miles of rough terrain, challenge and overcome the great Montezuma, he would have to be all of that and more. But there were two sides to Cortes. One was the great fighter and the other, the great lover.

Upon reading about the personal life of Hernando, I found a revealing tidbit as to why he could not make one of Columbus' voyages as planned.

Being a great romantic, Hernando decided to woo his current love by climbing the tree directly in front of his paramour's bedroom window to proclaim his great love for her. He slipped and fell from the tree and broke his leg. Not only did his blunder ruin his chances for a romantic encounter, but also did the same for his voyage with Columbus.

In the years that followed, he put into place the circumstances for his own voyage to Mexico in 1519.

During the interval before 1519 he married the Governor's daughter (a political alliance, no doubt), but remained pretty much the "man about town." History tells us of Malinalli, the daughter of a Mexican tribal leader, who acted as his interpreter and mistress and bore him an offspring. One wonders where he found the time.

On the bottom right of the painting you will note a dog and the chestnut horse on which he is mounted. They went with Cortes on his voyage along with fourteen more horses, some dogs, four hundred men, and supplies to sustain them all through their journey. This also made it possible for them to cross many miles of rough terrain.

Since horses were not something the Mexican natives had ever seen, they were alarmed by what they thought were half men and half animals. The element of surprise was certainly on Cortes' side.

The natives at first thought the Spaniard was the god Quetzalcoatl, who had at one time promised to return. But Cortes soon made himself known for what he was — a deeply religious man who quickly tore down many sacrificial altars and saved many who would have joined the thousands that went before them into giant tombs. He then proceeded to overcome Montezuma.

Having learned all that, I had to find someone who would fill this man's shoes!

In early February of 1991 I met Thomas Catapano, an Assemblyman at the time. He attended a meeting in my husband's office sporting a trim beard, mustache, and had the dark Spanish looking eyes of the *Conquistador*, Hernando Cortes. When I asked if he would mind representing the conquerer/ explorer whose reputation was questionable, he

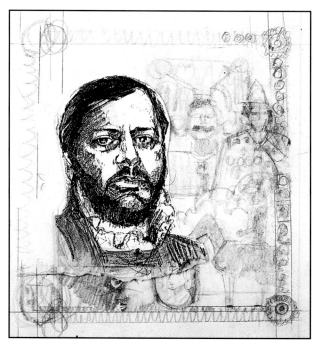

A thumbnail pencil sketch serves as a rough layout for the finished painting.

thought only a second and replied that any man that could accomplish all of that and have so many lady friends has to be recognized as someone to remember.

It was my pleasure then to follow up with Tom's sitting for the Hernando Cortes portrait. Tom has a sparkling quality in his eyes that added a most effective dash to the daring *Conquistador*.

And for me, through my models, all of the series explorers continued to become alive and well and living in the twentieth century.

Portrait: HERNANDO CORTES / "AGE OF DISCOVERY NAVIGATORS"
by Constance Del Vecchio/Maltese

LEGEND

On the upper right is a gold carved breast plate. Just below, Montezuma appears in tribal finery. On the lower right, Cortes is mounted on his dark chestnut horse alongside one of his dogs that traveled with him. In the center, below Cortes is his interpreter and mistress, Malinalli, who bore him a child. Cortes' Coat of Arms is on the lower left.

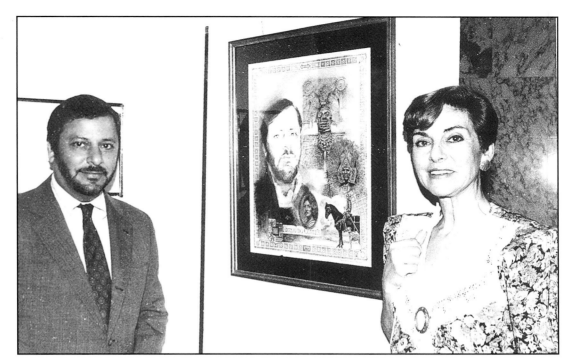

◆ Tom Catapano and Constance stand next to the Hernando Cortes painting at the Albany exhibit.

◆ Presentation of Hernando Cortes painting to Assemblyman Tom Catapano at Italian-American Legislators' Weekend. Senator Nicholas A. Spano is presiding.

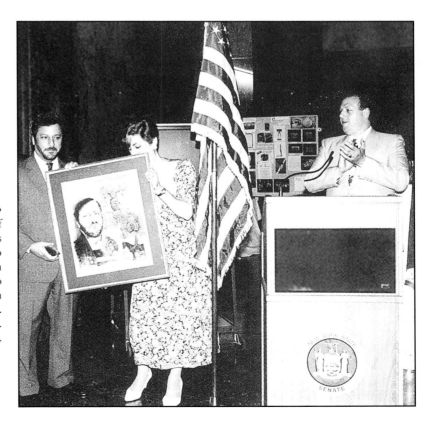

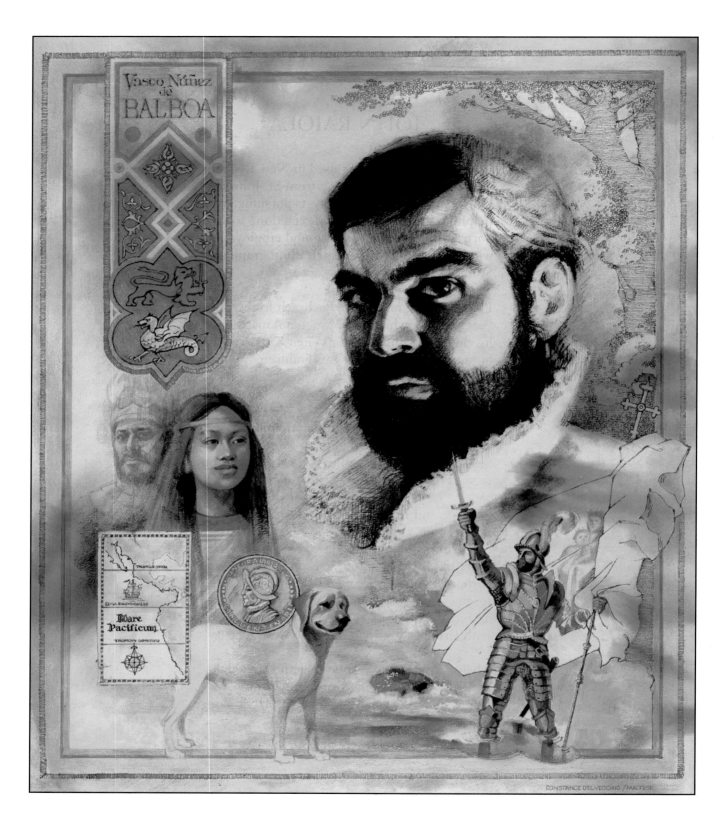

THE DISCOVERER OF THE PACIFIC OCEAN WAS A VIBRANT MAN OF IRON WHO BEGAN HIS EXPLORING CAREER AS A STOWAWAY ABOARD CAPTAIN ENSISCO'S SHIP ENROUTE TO "TIERRA FIRMA." BECAUSE OF HIS REPUTATION AS A SWORDSMAN AND WARRIOR, HE WAS WELCOMED INTO THE CREW RATHER THAN PUT ASHORE

JOHN RAIOLA

I was born in 1958 and raised in New Rochelle, New York. After graduating from St. John's University, I found my interests pursuing artistic photography. As such it directed me toward portrait photography and I found employment with the prestigious Bachrach Photographic Studio in Manhattan.

I was a photographer for Bachrach for eight years, during which time I met and married my lovely wife, Kim, in 1986. When Kim isn't home taking care of our two children, Stephen, 9, and Erin, 6, she is at business working for Fuji Film as a marketing sales manager.

I met Constance while photographing her at the Bachrach Studio. Thereafter, I grew my beard for Balboa and came to a career decision to start my own studio in New Rochelle.

My wife and I invested in an older home, which has become a labor of love in renovation. If I'm not working about the house (a good part of my spare time) I'm trying to get some quality time with my children. Stephen belongs to a baseball league — that is, worth spending time with — and just keeping lines of communication open with Erin is a gratifying experience.

I belong to the New York Athletic Club and will, if time allows, give more time to those things men do when the house is further along.

JOHN RAIOLA

I was born in 1958 and raised in New Rochelle, New York. After graduating from St. John's University, I found my interests pursuing artistic photography. As such it directed me toward portrait photography and I found employment with the prestigious Bachrach Photographic Studio in Manhattan.

I was a photographer for Bachrach for eight years, during which time I met and married my lovely wife, Kim, in 1986. When Kim isn't home taking care of our two children, Stephen, 9, and Erin, 6, she is at business working for Fuji Film as a marketing sales manager.

I met Constance while photographing her at the Bachrach Studio. Thereafter, I grew my beard for Balboa and came to a career decision to start my own studio in New Rochelle.

My wife and I invested in an older home, which has become a labor of love in renovation. If I'm not working about the house (a good part of my spare time), I'm trying to get some quality time with my children. Stephen belongs to a baseball league — that is, worth spending time with — and just keeping lines of communication open with Erin is a gratifying experience.

I belong to the New York Athletic Club and will, if time allows, give more time to those things men do when the house is further along.

Vasco Nuñez de Balboa

I was still working feverishly to finish Cortes when it was suggested to me that I should get a good picture of myself for publicity purposes. Since the entire series had to be finished by the end of 1991 in order to make a 1992 calendar, I was beginning to feel the pressure of the deadline once more.

Okay, where can I find a photographer who would be kind to a mature woman and not show every little detail on the face yet retain the resemblance? That particular trick is easier to do with paint and canvas than with a critical lens.

My husband had used a photographic studio that had a good rep doing political figures and celebrities. It was located in Manhattan, was a bit expensive, but worth it. After doing a fantastic makeup job, brushing my hair just so, and wearing my most flattering blouse, I left my studio. I took a black turtleneck sweater along (an artist's uniform) to change into for an alternate pose.

When I arrived I was escorted into a studio upstairs and told that John Raiola would be taking care of me.

I had a chance to check my lipstick before John came in and introduced himself. He was about six feet tall, young and very attractive. He started posing me in various seated positions while adjusting lights and asking me what I had intended for the photos we were taking. While I realized he probably was asking me questions in order to put me at ease (a trick I use myself with my models), I was happy to tell him of the Quincentenary Series and about the explorers.

"In fact," I said, "Balboa is the next explorer I'll be painting, and he – Balboa – is quite an interesting character. Trying to escape his creditors, he actually came to the New World as a stowaway. A sailor friend told him of a ship that was making a voyage to Darien to relieve Captain Ojeda, who was in need of

← I took dozens of pictures of John – any one of which would have been great!

53

supplies. The friend helped Balboa by hiding him and his warrior dog on board ship for two weeks — long enough for him to not be put ashore when he was revealed. Balboa was an excellent swordsman. His dog had fought gallantly by his side and earned medals of his own.

The captain of the ship allowed Balboa to join his crew, and when they landed in Darien, Balboa befriended a tribe of Indians whose leader was named Comogre. As fate would have it, Comogre had a daughter, and Balboa took her as his wife.

I noticed John was really listening when he started asking me questions about Balboa.

"How old was he?" he asked.

"A young rascal," I answered. "He was thirty-five, a redhead, and had dark flashing eyes. In fact, you would make a terrific model for my Balboa except you would need a beard."

"When would you be ready to do the Balboa painting?" John asked.

"Oh, not for another six to eight weeks," I answered, "since I'm still working on Cortes."

"I can grow a beard in six weeks. My hair grows very fast. And if I promise my wife that I'll shave it off right after, she'll be happy."

Serphin and I went to his home in New Rochelle for the sitting. We met his wife and beautiful baby boy, and reassured his everlovin' that the beard would indeed go right after my painting was finished.

That's how I acquired the handsome rascal who is Balboa in my series. The added advantage of having a photographer help me was the photo tips that he gave me to get the effect that I wanted for that dramatic look in his wonderful eyes.

As you can see, he did a marvelous job with my photo, and I was overjoyed with Balboa!

Portrait: VASCO NUÑEZ DE BALBOA / "AGE OF DISCOVERY NAVIGATORS"
by Constance Del Vecchio/Maltese

LEGEND

At the upper left is a border design with the Balboa Coat of Arms. The mid-left background depicts Governor Davila, who ultimately had Balboa beheaded at the age of forty-five. In the mid-left foreground is the "Careta" Indian Princess who married Balboa. On the lower left is an antique map of the Pacific Ocean, and to the right is a Panamanian coin minted in Balboa's honor. Below at the center is Leoncicco, Balboa's warrior dog who accompanied him on his explorations. On the bottom right, Balboa claims the Pacific Ocean in the name of the King and Queen of Spain.

Balboa's coat of arms was less ornate than the tapestries of the time, so I combined the two to create the proper atmosphere.

"Balboa's discovery of the Pacific" pencil study. I kept moving this section in the composition until the sword pierced the beard. This worked!

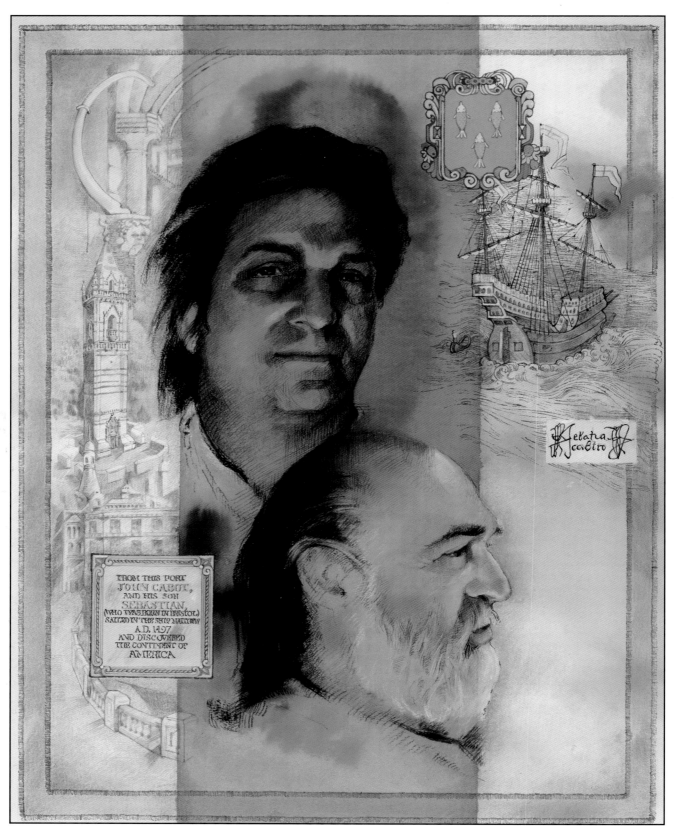

IN 1497 THIS FATHER AND SON GENOESE TEAM WAS SENT BY THE KING OF ENGLAND TO THE NEW WORLD, WHERE THEY DISCOVERED NEWFOUNDLAND. ON THEIR NEXT VOYAGE THEY ENCOUNTERED STORMS AND THE OLDER CABOT WAS NEVER AGAIN HEARD FROM

MARVIN SYLVOR

I was born in the Bronx, New York on April 21, 1934, attended Long Island University and received a business degree. I later went to Pratt, which was a good background for any artistic endeavors I would pursue in my career. As it happened, when I was inducted into the Army at Fort Dix, I had the good fortune to not only be stationed in Hawaii but also to be made the Artist in Residence.

One day the sergeant addressed all of us, asking if there was a painter among us. He asked the fellow down the line who raised his hand, "Do you have your own brushes?" When he replied, "No," the sergeant passed him and went on to the next one who raised his hand, asked the same question and got the same reaction. Then I raised my hand. He asked me the same question, only I replied, "Yes." He said, "Good, report to me tomorrow and I'll show you your studio."

When we were dismissed for the day, I quickly ran in to town to find a store that sold brushes, bought myself a supply and reported the next day for my induction into the art world. It's a tough job, but somebody has to do it.

If it were not for the taste in paints that I received at that time, who knows where I would be today. However, in 1983, when I was called upon to rescue a dilapidated carousel in the heart of Forest Park in Queens County, New York, I rallied to the aid of the carousel and formed what is known today as Fabricon Carousel Company. When I inspected the carousel, I realized that it was the last remaining complete carousel by the most esteemed carousel carver in American history, Daniel Muller. Fabricon took on the restoration as a labor of love, completing the sixty-foot, three-step carousel for a 1985 grand opening. To this day, the carousel continues to delight the community and draw visitors from all over the world.

It was during the time of the restoration that I met Constance and she told me of *her* labor of love. She asked me if I'd be interested in being the elder Cabot. You know the answer to that, especially since she had also finished a potrait of "Forest Park Beauty" (one of the carousel horses) and presented it to me as a means of publicity for the carousel.

I will continue with Fabricon as a lover of the Carousel and pursue the art of discovery and restoration.

MARVIN SYLVOR

I was born in the Bronx, New York on April 21, 1934, attended Long Island University and received a business degree. I later went to Pratt, which was a good background for any artistic endeavors I would pursue in my career. As it happened, when I was inducted into the Army at Fort Dix, I had the good fortune to not only be stationed in Hawaii but also to be made the Artist in Residence.

One day the sergeant addressed all of us, asking if there was a painter among us. He asked the fellow down the line who raised his hand, "Do you have your own brushes?" When he replied, "No," the sergeant passed him and went on to the next one who raised his hand, asked the same question and got the same reaction. Then I raised my hand. He asked me the same question, only I replied, "Yes." He said, "Good, report to me tomorrow and I'll show you your studio."

When we were dismissed for the day, I quickly ran in to town to find a store that sold brushes, bought myself a supply and reported the next day for my induction into the art world. It's a rough job, but somebody has to do it.

If it were not for the taste in paints that I received at that time, who knows where I would be today. However, in 1983, when I was called upon to rescue a dilapidated carousel in the heart of Forest Park in Queens County, New York, I rallied to the aid of the carousel and formed what is known today as Fabricon Carousel Company. When I inspected the carousel, I realized that it was the last remaining complete carousel by the most esteemed carousel carver in American history, Daniel Muller. Fabricon took on the restoration as a labor of love, completing the sixty-foot, three-step carousel for a 1985 grand opening. To this day, the carousel continues to delight the community and draw visitors from all over the world.

It was during the time of the restoration that I met Constance and she told me of her labor of love. She asked me if I'd be interested in being the elder Cabot. You know the answer to that, especially since she had also finished a portrait of "Forest Park Beauty" (one of the carousel horses) and presented it to me as a means of publicity for the carousel.

I will continue with Fabricon as a lover of the Carousel and pursue the art of discovery and restoration.

JOHN AND SEBASTIAN CABOT (CABOTO) 12

Having turned Columbus down when he was looking for funds to make his first voyage, England started to take notice of the New World after 1492. King Henry VII now approached another Genoese, John Cabot, to sail under the English flag for the purpose of discovering new land beyond the Atlantic waters.

In March 1496 John Cabot and his three sons received a Royal Charter from the King, authorizing them to compete, but not interfere, with Spain and Portugal in the search for "heathen" land unknown to Christendom.

On May 2, 1497 John Cabot sailed from Bristol in the Matthew, a small vessel with only eighteen men — his son Sebastian being one of them — and anchored somewhere between Halifax and Labrador, probably on June 24, 1497. Trading vessels sailed following this initial voyage, and a few years later

the elder Cabot disappeared. His son Sebastian told of his father's death at sea, but was not clear about the circumstances.

Sebastian Cabot appears to have devoted himself entirely to nautical science, attaining such eminence that, on the death of Columbus, the King of Spain engaged his services as cartographer at a salary of 30,000 *maravedas*. While in the employ of Spain, Cabot made his "Mappamundi," or Map of the World. This famous map, which not only presented his and his father's discoveries but also those of Spain and Portugal down to his own time, was drawn on parchment and illuminated with gold and colors. The original was sold in 1575 on the death of the President of the Council of the Indies, and never has been heard of since.

Since this was the last discoverer in the series before I planned to do "The Admiral of the Ocean Sea" (the older Columbus), I began to introduce more color in the images so that I could logically do a full color of the last one. I wanted to have a gradual introduction of color rather than a drastic change for the final painting.

Another challenge was having two portraits in the same painting. I had not only found a credible John Cabot, but also someone who resembled him enough to be his son Sebastian.

At the same time that I was doing this series, I had befriended the restorer of the Forest Park Carousel, Marvin Sylvor. He had

◆
Marvin sat for me at his Carousel studio. I was able to get what I needed very quickly so as not to keep him from his restoration work.

taken time to show me the marvelous old Muller horses as they were being restored. While I was thoroughly fascinated with the entire process, I made a mental note of Marvin's strong facial features while he was speaking to me. It was now spring of '91 and time was growing short. Yes, he would take time off to sit for me, but I had to come to his studio. No problem! However, since I wanted to use the very prominent bony structure of his face as a focal point of the painting, the son would more than likely have similar characteristics.

Again I used my husband's assistance in asking him to be on the lookout for a likely candidate. Not much time went by as I proceeded to create the composition that would be Caboto.

You'll note that in the painting I use a blank space in front of the elder's profile, thus emphasizing the nose, and a full face for Sebastian directly above him. This showed the nose both full-faced and in profile. In all of the paintings I used a technique of dropping wet tea from a teabag onto a wet surface of the watercolor board to give an antique look to the background — a convincing device not only to provide an aged look to the paintings but also to add atmosphere. In the Cabot painting the tea took on a darker look in several spots. However, I thought I would work with it and make the young Sebastian's eyes stand out more. It also gave him a swarthy look (no doubt all that sea air!).

Happy with my Father and Son, I cleared the decks for the Admiral of the Ocean Sea.

Portrait: SEBASTIAN AND JOHN CABOT
"AGE OF DISCOVERY NAVIGATORS"
by Constance Del Vecchio/Maltese

LEGEND

On the top left is a rib of a whale, the only remaining relic, in St. Mary Redcliffe Church. Below are Cabot Memorial Tower and the tablet on St. Augustine's Bridge in Bristol. From top right is the Cabot Coat of Arms and the ship Matthew at landfall off Newfoundland. Under the ship are their signatures.

◄ Map of Cabot's first voyage, 1497.

*King Henry VII
now approached another
Genoese,
Giovanni Caboto . . .*

The Cabot Memorial Tower of Brandon Hill,
from "The Cabots and The Discovery
of America" by Elizabeth Hodges.

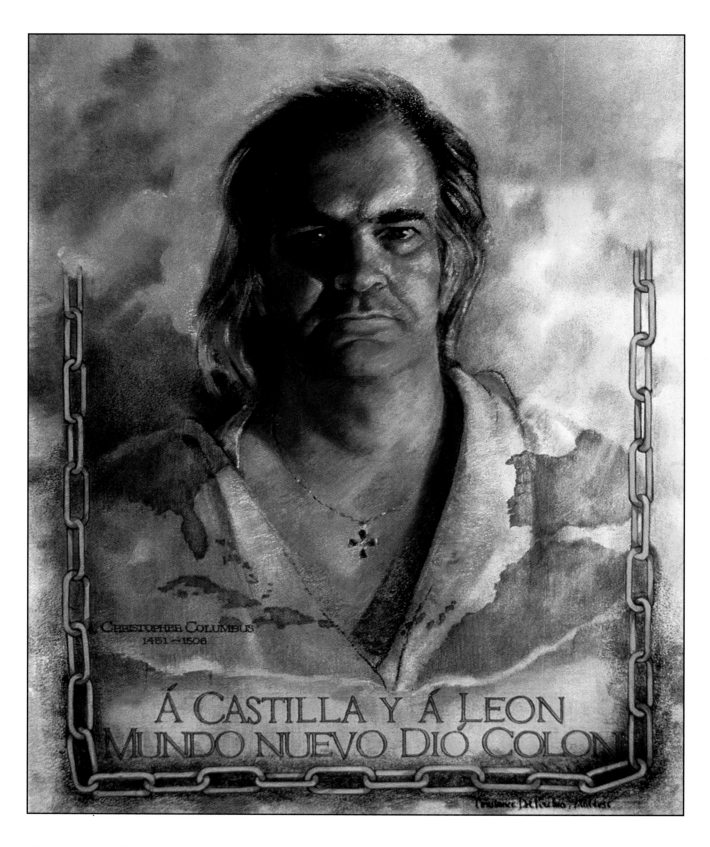

CHRISTOPHER COLUMBUS
1451 ~1506

Á CASTILLA Y Á LEON
MUNDO NUEVO DIÓ COLON

COLUMBUS: DETERMINED DESPITE HIS CHAINS

SERPHIN R. MALTESE

I was born in Corona, New York on that "day of infamy," December 7, but in 1932. My father, Paul Maltese, and my mother, Frances Scafidi-Maltese, moved soon after to the lower east side of Manhattan, where I graduated from P.S. 63, J.H.S. 64, and Stuyvesant High School. After military service, I went to Manhattan College on a Regents scholarship, and received a B.A. degree. I was awarded a war service scholarship and received an LLB and JD degree from Fordham University Law School. In 1963 I was admitted to the New York State Bar and to practice before the U.S. Supreme Court.

The oldest of four children, I have a brother Vincent, who now serves as president of the Triangle Factory Fire Survivors Association and Vice President of Italian Charities, a sister, Paula, who resides in Florida with her children and grandchildren, and our youngest brother, Andrew, who resides in and was Mayor of Weedsport, New York.

I served in the 45th Infantry Division during the Korean War, and after being honorably discharged met Constance, fell in love, we married in 1955 and had two lovely daughters, Andrea and Leslie. They are now married — Andrea to Arthur Spanarkel and they have a beautiful daughter, Genevieve, and Leslie to Jim McGill. They have two wonderful girls, Sondra and Eva, with another blessed event due in November 2000.

Prior to my election as Senator, I served as a Queens Assistant District Attorney and Deputy Chief of the Homicide Bureau. Since both Constance and I were interested in politics, in 1962 we became involved in the formation of what was then a new political party — the Conservative Party. I became the party's State Executive Director in 1972 and the New York State Chairman in 1986. In 1988 I was elected to the New York State Senate, at which time I resigned as Party Chairman.

In addition to the honor of posing for the Admiral of the Ocean Sea, I am affiliated with many civic and community organizations, including Juniper Park Civic Association, Glendale Kiwanis, Queens Chamber of Commerce, Sons of Italy-Mario Lanza Lodge, Italian American Legislators, Italian Charities, Italian American Business Association, Stuyvesant High School Alumni Executive Board, and Chairman of the Board of Christ The King High School.

While receiving many awards and honors over the years, I take particular pride in the following: I had the honor of being the recipient of the St. John's University President's Medal and the LaGuardia Community College President's Medal. I also received the New York State Catholic Conference's Year 2000 Public Policy Award for "courageous public service in defense of innocent human life," and most recently the President of the Republic of Italy conferred upon me The Order of Merit and the title of *Cavaliere*.

SERPHIN R. MALTESE

I was born in Corona, New York on that "day of infamy," December 7, but in 1932. My father, Paul Maltese, and my mother, Frances Scaidi-Maltese, moved soon after to the lower east side of Manhattan, where I graduated from P.S. 63, J.H.S. 64, and Stuyvesant High School. After military service, I went to Manhattan College on a Regents scholarship, and received a B.A. degree. I was awarded a war service scholarship and received an LL.B and JD degree from Fordham University Law School. In 1963 I was admitted to the New York State Bar and to practice before the U.S. Supreme Court.

The oldest of four children, I have a brother Vincent, who now serves as president of the Triangle Factory Fire Survivors Association and Vice President of Italian Charities; a sister, Paula, who resides in Florida with her children and grandchildren; and our youngest brother, Andrew, who resides in and was Mayor of Weedsport, New York.

I served in the 45th Infantry Division during the Korean War, and after being honorably discharged met Constance, fell in love, we married in 1955 and had two lovely daughters, Andrea and Leslie. They are now married — Andrea to Arthur Spanarkel and they have a beautiful daughter, Genevieve, and Leslie to Jim McGill. They have two wonderful girls, Sondra and Eva, with another blessed event due in November 2000.

Prior to my election as a Senator, I served as a Queens Assistant District Attorney and Deputy Chief of the Homicide Bureau. Since both Constance and I were interested in politics, in 1962 we became involved in the formation of what was then a new political party — the Conservative Party. I became the party's State Executive Director in 1972 and the New York State Chairman in 1986. In 1988 I was elected to the New York State Senate, at which time I resigned as Party Chairman.

In addition to the honor of posing for the Admiral of the Ocean Sea, I am affiliated with many civic and community organizations, including Juniper Park Civic Association, Glendale Kiwanis, Queens Chamber of Commerce, Sons of Italy-Mario Lanza Lodge, Italian American Legislators, Italian Charities, Italian American Business Association, Stuyvesant High School Alumni Executive Board, and Chairman of the Board of Christ The King High School.

While receiving many awards and honors over the years, I take particular pride in the following: I had the honor of being the recipient of the St. John's University President's Medal and the LaGuardia Community College President's Medal. I also received the New York State Catholic Conference's Year 2000 Public Policy Award for "courageous public service in defense of innocent human life," and most recently the President of the Republic of Italy conferred upon me The Order of Merit and the title of Cavaliere.

ADMIRAL OF THE OCEAN SEA 13

Since we already established that Serphin had inspired the Young Visionary, it seemed only natural that I would again approach Serphin to pose for the older Columbus. He certainly would have aged the same way.

"Serf," I said, "I need someone who looks a little weather-worn and wise for the older Columbus. How about giving me a few hours of your time in exchange for my making you immortal as the Admiral of the Ocean Sea?"

After I convinced him that I was only teasing about being weather-worn, he seemed pleased that he would be portraying the great navigator.

It was now the summer of '91 and I was beginning to look at the end of the tunnel timewise. Admittedly, I was a little impatient as I posed Serf for the Admiral of the Ocean Sea. I would ask him to look at me in a certain way and he would say, "Why?"

I'd move the lights to emphasize his features and he would complain that the light was shining in his eyes. He started fidgeting and asking how much longer he would have to hold the pose. When I told him he'd only been there ten minutes, he began to appreciate the trials of the models. I took the photos as quickly as I could, since it was clear that Serphin would never last a full two hours. If they didn't turn out as well as they should, I would have to sit him once more.

Luckily, I had what I wanted in the photos and I then proceeded to complete my last painting of the series.

In August, as I approached completion of the painting, Professor Paolucci brought to my attention the poem by Tennyson entitled "Chains." It was about the chains that bound the Admiral of the Ocean Sea when he was

CHAINS

Chains for the Admiral of the Ocean! chains
For him who gave a new heaven, a new earth,
As holy John had prophesied of me,
Gave glory and more empire to the kings
Of Spain than all their battles! chains for him
Who pushed his prows into the setting sun,
And made West East, and sail'd the Dragon's mouth,
And came upon the Mountain of the World,
And saw the rivers roll from Paradise!

— Alfred Lord Tennyson

brought back after his third voyage to the New World. Thus inspired, I incorporated the chain design as a frame around the older Columbus. I did not paint the chains entirely around the painting, since after Columbus' death he was free — there are clouds above his head. I kept his face the same as Serf's, with the exception of his eyes, which are hazel, not blue, and his hair, which is short, not long as I depicted Columbus'. I kept the Maltese Cross neckpiece, an anniversary gift from me, in the painting.

There are several sites that claim to have Columbus' remains. One is the tomb in Spain

where the stone is engraved with the words as at the bottom of my painting.

I was particularly proud of the way I superimposed the map of the New World on Columbus' right shoulder and the Old World on his left. It appears at first to be a design on his cloak until you realize what it is.

At last — the end.

But was it really? No, now, while I was receiving considerable attention, I began to reflect on the time (years) and energy spent. The series was featured as an exhibit at the Society of Illustrators for the Quincentenary, the Intrepid Sea Air Space Museum, St. John's University, Queensborough Community College, Westchester Community College, Manhattan Community College (among others), and at many elementary and middle schools.

As an artist, it is always great getting compliments and notice, however, having been a commercial artist for many years, it was only natural that I began to explore the commercial aspects of the exhibit. The business end of this was a whole other experience, but finally, there were commemorative plates made for the Quincentenary, as well as calendars and posters. I created postcards from the paintings with a very good lithographer and designed an envelope to put them in — thereby creating a neat gift package that was sold at the Intrepid Sea Air Space Museum and elsewhere.

At the completion of the Quincentenary Show at the Society of Illustrators, a *New York Times* photographer came to take pictures of the paintings and the people who posed for them. When the article appeared in the Sunday Times, the heading read "At Last We Know What Columbus Looked Like. He Looked Like Senator Maltese."

I had kept my promise to Serf. I made him immortal!

Portrait: CHRISTOPHER COLUMBUS / "ADMIRAL OF THE OCEAN SEA"
by Constance Del Vecchio/Maltese

LEGEND

The words on the bottom of the painting were engraved on Columbus' tombstone in Spain. On the left shoulder of his cloak is a map of the Old World, and on his right shoulder is a map of the New World. Forever the Admiral of the Ocean Sea!

Senator Serphin Maltese and artist wife Constance Del Vecchio/Maltese stand in front of display in the lobby of the Empire State Building for the Columbus Day celebration.

First pencil study of the Admiral shows a stern and determined man.

◆ One of Constance's proudest moments — being honored by
Queens Borough President Claire Shulman for Italian Heritage Month,
with Jack Como looking on.

CONSTANCE DEL VECCHIO/MALTESE

Born in the midst of the great depression, Constance was nonetheless fortunate for having parents—although from different parts of the world (Italian-American father and German mother) sharing an artistic heritage.

The solitary activities of drawing, painting and playing the piano seemed natural directions for an only child spending time alone. It was then an easy step to be known as the class artist in school and progress quickly to acquiring her first art award in junior high. When it was clear that Constance wished to pursue the arts as a career, she was encouraged by her art teacher to attend the School of Industrial Arts (now known as the School of Art and Design).

After graduation her mother took her to Europe not only to meet her artist cousins, but also to broaden her artistic horizons. Upon returning to New York, she attended Parsons' School of Design, where she acquired a scholarship, and the Art Students' League of New York.

She embarked on her art career with

Norcross Greeting Cards, after which she became Art Director for Pfizer Pharmaceuticals, doing illustrations and graphics for their booklets and brochures. It was then that she met her soon-to-be husband, Serphin, through their mutual friend and future best man, John DeFazio.

Since Serf was just home from the Korean conflict, he had not yet attended college. They both decided that he would go to college while Constance continued in her own business — freelancing in commercial art (illustratiions and graphics) as "Maltese Design Studio." They were married and had two lovely girls, Andrea and Leslie. Andrea has since married Arthur Spanarkel and presented Constance with a beautiful granddaughter, Genevieve. Leslie also married, to James McGill, and has two lovely girls, Sondra and Eva, and at this writing awaits a baby boy.

While running her own studio in Manhattan, Constance acquired a prestigious client list — Random House, Harcourt Brace Jovonovich, Regents, Dodd Mead, "My Baby" magazine, Johnson and Johnson, New York Stock Exchange, J. Walter Thompson, Kodak, U.S. Marines, Thomas Electronics, National Society to Prevent Blindness, and New York Diabetes Association.

It was in 1987 that Constance discussed with Dr. Anne Paolucci her desire to change her direction and enter the "fine art" world through portraiture. Dr. Paolucci was the president and founder of Columbus Countdown: '92, an organization dedicated to the celebration of the 500th anniversary of Columbus' landing in America. As this book demonstrates, the Discoverers were a four-year investment in time and love.

Currently a member of the prestigious Society of Illustrators, Portrait Society of America Inc., and the National Arts Club, Constance is a board member of both the Queens Theatre in the Park and the Queens Council on the Arts, where she also served as president.

Among her many awards are:
- International Film Festival Award — Johnson and Johnson
- Arts and Humanities — Columbus Countdown: '92
- Artistic Excellence — Columbia Association
- Woman of the Year — Italian Charities
- Woman of the Year — Italian Businessmen's Association
- Arts and Humanities — Sons of Italy (Mario Lanza Lodge)
- Citation of Honor — Queens Borough President Claire Shulman
- Citation of Honor — LaGuardia Community College
- Flame of History and Culture Award — Central Queens Historical Association
- Lifetime Achievement Award — Italian American Electorate
- Mayor's Commission on the Status of Women — Mayor Giuliani
- Governor's Award for Excellence — Governor Pataki

Her paintings have been shown in museums, galleries, expositions, exhibitions and Italian American Heritage presentations at the State Capitol, the Nation's Capitol, other states, New York City Hall, Queens Borough Hall, the Queens Museum, Maspeth Town Hall, and featured in a major two-year exhibition at the Intrepid Sea Air Space Museum.

Some of Constance's commissions include Judge Dominick DiCarlo, Assembly Speaker Stanley Fink, Ambassador Charles Gargano, Assemblyman Anthony J. Genovesi, Senator Efraim Gonzalez, Judge Robert Hanophy, Judge Alfred Lerner, Consul General Franco Mistretta, The Honorable Susan Molinari, Mrs. Margaret Pataki, and Senator Mary Lou Rath.

"I Remember Mama"

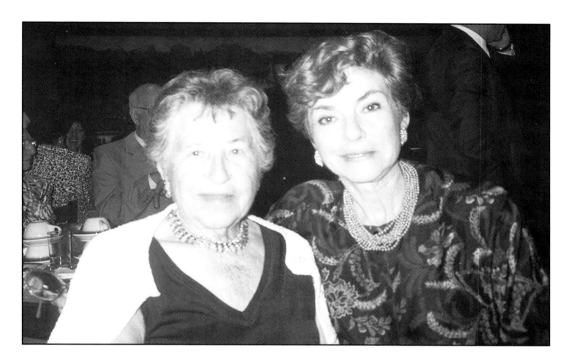

Else Hinkel Del Vecchio

Whenever she could, Mom would accompany me to the exhibit openings and lectures. I had started the Discoverer Series back in 1988. My Dad, although very ill, was still able to sit by his favorite window in the family room in Sarasota, Florida, and look out at the exotic birds that flew into the garden next to the lake. Dad had developed emphysema in his later years due to smoking two to three packs of cigarettes a day, and was now hooked onto a portable oxygen tank to aid his breathing. Mom, being his main caretaker, was more or less confined to the house and was away only long enough to do some shopping. They would come up to New York in the summer months (Mom doing the driving and Dad with his oxygen tank in the back seat) and stay with me.

It was now late 1988. Serf and I took a winter break down in Florida, bringing my art supplies and reference books on Christopher Columbus. We had our own rooms at Mom and Dad's, and always felt it was our home as well. Mom could now have a little time to herself, since we could spell her from time to time, and of course we enjoyed the Florida sunshine. Siesta Key beach being so close,

Mom, Dad, Serf and I would make it to the coral sanded beach for the morning and enjoy lunch there at a pine tree-shaded picnic table. Mom and I would take a long walk along the shore while Serf kept Dad company.

It was in the afternoon, while Mom would be making our dinner, that I would read aloud to my Dad from the books on Christopher Columbus. That accomplished two things. First, reading aloud kept the dates and geographical locations more clearly in my mind (history not being something I was too great in), and second, Dad's response and interest in the entire process. In the evening I could make rough sketches and layouts in my room while Serf either watched television or read. Since this was the first of the series (although I didn't know at the time that there would be more coming after the Young Visionary), I took a great deal of time working out the layout and the design of the painting. Mom gave me her critique (she always did), and while I sometimes got a little annoyed at her finding fault with anything, I had to admit that she almost always made a good point.

I finished the first layouts and design in Florida, and after our trip home I completed the Young Visionary and continued on. By spring, Mom and Dad traveled up to the lake house at Westerlo, where they stayed with us. It was during that spring and summer that several of the other discoverers were completed, and in September of 1989 my Dad passed away. While he didn't see the project to completion, I was glad he was able to be a part of and enjoy the completed Young Visionary.

Mom attended the first COLUMBUS COUNT-DOWN: '92 Dinner at the 200 Club, and from that point on considered herself my main public relations person. When she went back home to Florida for the winter, she brought my Young Visionary Prints to the schools in the area for the purpose of display for the Quincentenary. After she learned that the Intrepid Sea-Air-Space Museum would have my exhibit for three years, she made it her business to come and see that they were displayed properly.

When the Baker's Dozen were completed (the end of 1991), Publix Supermarket bought my Discoverers to make commemorative plates, calendars, and posters. Mom was tickled pink, because there was a huge mall being built on Tamiami Trail near her home, and the main store was Publix

Supermarket. Now she could go there and let everyone know that the Columbus on display was her daughter's work.

On the first day it was to be displayed, Mom called her best friend, Laura Lugo, and decided to go shopping. Upon arriving there, they noticed the huge display rack, but didn't approve of its location! They went to the manager and explained that the Columbus display should have more prominence and be moved center front. They complied!

I was also asked to go on a promotion tour in Dade County, Florida for two weeks, visiting two Publix Supermarket a day and sign plates and posters that people bought. Serf couldn't go with me because being a Senator can be somewhat demanding. (I also made it a point not to let them know that my husband was a Senator, since I did not want any favoritism because of that.) Mom was incensed that her daughter, a woman alone, should be traveling in Dade County all by herself. She therefore informed me that she would take a shuttle plane from Sarasota to Miami and travel with me. She was not going to allow her daughter to become prey to muggers or any other "no good" that might see a woman alone as a target.

No point in arguing, and I'm glad I didn't. Mom was not only a deterent to any assasins that might have come along, but really was great company. As I would be speaking to the customers in the stores, Mom sat nearby with her knitting and enjoyed the attention that she felt I so richly deserved.

We had a driver, Maurice, who took us from store to store. Mom and Maurice hit it off so well that he also referred to Mom as Mom.

Toward the end of the two-week stay, Serf phoned and said he could join me for the weekend and travel home with me. Mom, being a good mother-in-law, said she then would make her departure back to Sarasota and give me over to Serf.

THANK YOU, MOM, FOR EVERYTHING.
BORN: DECEMBER 7, 1909 — DIED: DECEMBER 16, 1995

LECTURES
AND EXHIBITS

One of the many pleasures of this project was reaching the children. After the completion of the Discoverers, I was asked to interpret and explain the many designs and information that surrounded the main image on the painting. The paintings were being shown at the Intrepid Sea-Air-Space Museum for the period that covered the Quincentenary. Therefore, many schools had field trips that went there to see the replicas of the Nina, Pinta and Santa Maria docked at the Intrepid's pier, then came through the AGE OF EXPLORATION exhibit, which included my display.

I would at that time give a lecture that told the children (mostly from nine years old to early teens) all about the explorers displayed there, how they were painted, and the history involved with each.

I also traveled to many schools (mid-schools, high schools and universities) with a separate set of prints of the Discoverers and lectured there.

After visiting the Louis Pasteur Middle School in early 1992 and receiving a celebrity's welcome, I gave a lecture on the Explorers, then opened the floor to questions. It was amazing to me how intelligent the questions were, not only relating to the history of the various explorers, but as to how I created the paintings and what mediums I used, etc. They wrote an article in their newsletter, *Pasteur Eyes*, about the visit and later sent me a copy.

Since Carol Monte's children had attended this Middle School, she decided it would be a nice gesture to return there on the day of my lecture to lend her support and extend her good wishes. It was particularly interesting since as she posed next to the portrait, one could see the striking resemblance to the portrait of Queen Isabella. It certainly added to the presentation of the lecture, and I appreciated the addition of her visit.

Most of the time as I visited different colleges and schools, I had to bring the easels and the thirteen paintings, prepare the display for the lecture, then after undo it all and pack to leave. It was a great deal easier at the Sea-Air-Space Museum exhibit. At the Intrepid Museum, my

Constance stands next to
her husband (Admiral of
the Ocean Sea) at the
start of the lecture in the
Intrepid Museum.

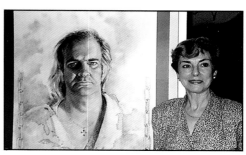

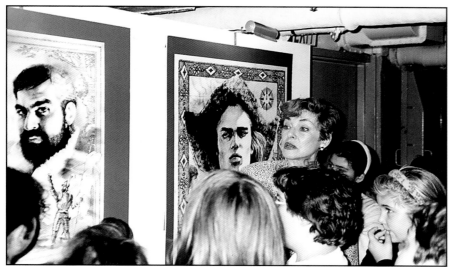

As you can see, many children crowd
around as the lecture continues. Here
they are being told of the discovery of
the Pacific Ocean by Balboa (or, as he
knew it, the South Sea).

Here at the Louis Pasteur Middle
School the children are being told of the
wonderful world of Discovery. You
might notice that the prints had to be
mounted on their separate easels,
thirteen in all. Lucky for me I had a
mini-van that was able to carry the easels
as well as the very well packed prints.

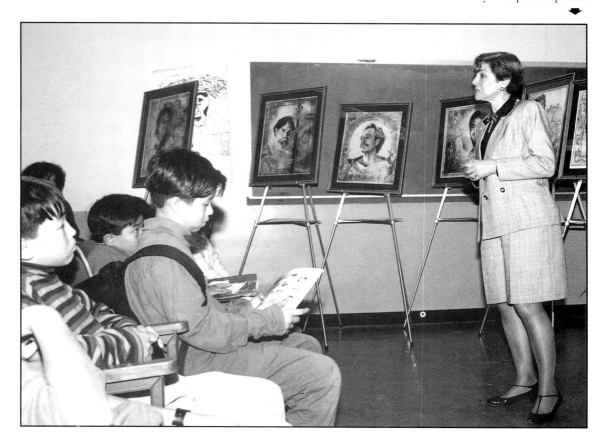

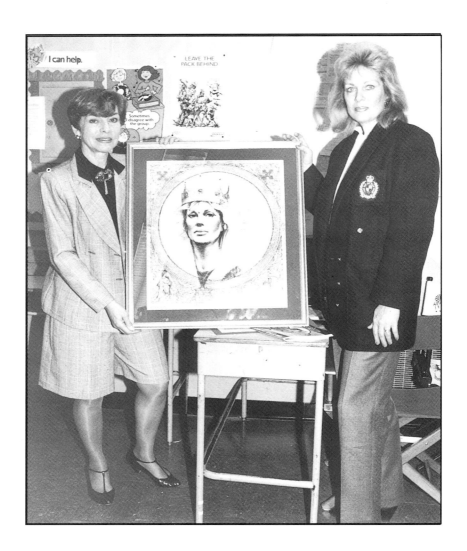

*. . . One could see the striking resemblance
as Carol Monte posed next to
the portrait of Queens Isabella at the
Louis Pasteur Middle School . . .*

paintings were duplicated in larger prints and
mounted with their legends in the Age of
Exploration section. They remained there for three
years.

I want to acknowledge a debt of gratitude to Larry
Sowinsky, Director of the Intrepid Sea-Air-Space
Museum, and his wife, Maria, for their invaluable
support in connection with the exhibit.

During that same time, I was still able to have
exhibitions at various schools and museums. I had
two sets of copies made plus the originals. That gave
me three in all to work with, plus the Intrepid set.

October, the most active time because of Columbus Day, there would be no shortage of Discoverers.

Serphin wanted a set for the Italian American Legislators weekend meeting at the Capital. They were prominently displayed in the "Well" of the Legislative Office Building and were the background for a festive Columbus Feast. Ron Baumann, who had posed for Henry Hudson, attended since he lived nearby on the Hudson River coast. Other models also attended, as you will see here in the photos. Upon seeing the portrait of the "Admiral of the Ocean Sea," Assemblyman Anthony Genovesi, chair of the organization that year, questioned who the model was. When I told him that Serphin had done the honors for that one, he smiled, looked at Serphin and told him that I was looking through the eyes of love.

Since it took almost four years to complete the series, I displayed the finished portraits at the Columbus Countdown: '92 Dinners. At the first of those dinners I received the Arts in the Humanities Award for the Young Visionary. There was a beautiful introduction by Dr. Paul Patané, followed by my first attempt at speechmaking. I was very nervous, especially since Paul made me sound like the Pope's answer to the Sistine Chapel, but as you can see from the photos, I soon overcame those doubts and started demonstrating my Italian heritage by tossing my hands about. My family helped by laughing and applauding at the appropriate times. It always pays to bring your own cheering squad.

Another highlight was the exhibit at the Society of Illustrators. I was chairperson for the Quincentenary Exhibition in 1992. This exhibition featured not only my own paintings but also paintings by other artists who had done works for the Columbus Celebration. We had a lovely reception for the opening and a grand crowd came. Steve Meyers from the *New York Times* took pictures of my paintings and the people that posed for them. It also kicked off other exhibits, since some that came asked if I would also come to their school or museum.

While the exhibits were a lot of work, they were also rewarding and a great learning experience for me. I always thought that just doing the painting was enough, but it is even more exciting to get feedback from the viewers. I once had a teacher who said, "Art for art's sake is like bridges for bridges' sake. It has to be used to be appreciated."

Never at a loss for words, Constance responds at the Columbus Dinner upon receiving the Arts in the Humanities Award. . .

← The Legislative Office Building (or LOB) Well was filled with attendees of the weekend celebration. The Discoverers lined the walls while viewers wined and dined.

ITALIAN-AMERICAN LEGISLATORS WEEKEND

"Who posed for Verrazzano?" he asked Constance at the exhibit. This became as much a point of interest as the art itself. →

"Unaccustomed as I am to public speaking . . . " Constance does just that at the Conference of Italian-American Legislators.

Serf and I took time to enjoy the fact that the weekend was a great success. The workshops were well attended, the food spectacular, and the exhibit beautifully displayed.

A friend, Bob Wieland, and his Mom came to join in the festivities.

Magellan (Frank D'Orazi) and his son, Francis, pose with the Senator (Columbus) at the Italian-American Legislative Conference.

Professor Henry Paolucci discusses the trials of Columbus at the Society of Illustrators, where Constance chaired the Quincentennial Show.

An exhibit was held at John Jay College. Constance and her husband, Serf, received a warm welcome from (l. to r.) a John Jay student, Dr. Lorraine Colville, and Sandy Lanzone of the Communications Skills Dept.

A Picnic On The Pier

NEW YORK STATE
CHRISTOPHER COLUMBUS QUINCENTENARY
COMMISSION
Tour of the NINA, PINTA, SANTA MARIA

•

"AGE OF EXPLORATION" Exhibit

•

Picnic Lunch — Entertainment

▲

Dolores Frank, Paul Sorvino, Dr. Anne Paolucci, Constance Del
Vecchio Maltese

Constance on board the "Nina" replica

▼

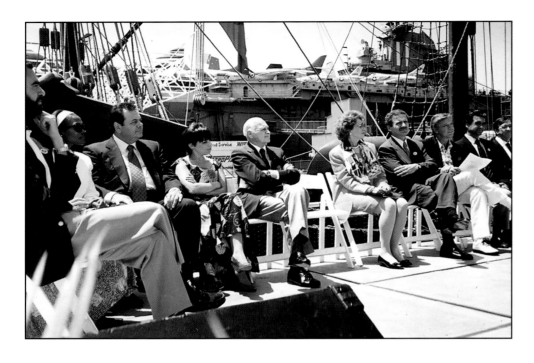

A host of dignitaries on the
Columbus Celebration dais
— Paul Sorvino and guest,
a great American, Zachary
Fisher, First Lady
Matilda Cuomo and guest,
Councilman Peter Vallone.

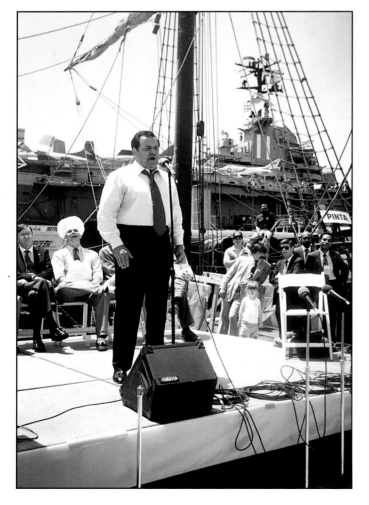

On board the Pinta, Paul Sorvino
sings an Italian medley of songs
to entertain the guests at the
Intrepid celebration.

*THE INTREPID
SEA-AIR-SPACE MUSEUM
hosted the Age of Exploration
Exhibit for three years.
It was here that the
lecture tours originated.*

MEDIA

I had the good fortune to have the Discoverer Series done in time for a wonderful opportunity. I was able to have them featured in a Quincentenary Calendar, Commemorative Plates, Posters, Cards and Prints. This was sponsored by a large company in Florida for the purpose of promoting the Five Hundredth

PLATES
POSTERS
CALENDARS
PRINTS
CARDS

Anniversary of the discovery of America. Four of the most popular images were used — The Young Visionary, Vasco Da Gama, Ferdinand Magellan and Juan Ponce De Leon. Ponce De Leon was the best seller in Florida, since he was best known for searching for the Fountain of Youth there. While on a two-week promotional tour there, I appeared in two stores a day, signed posters, plates, and what I called my Playboy Calendar, since every month had a different Discoverer. My only disappointment was that Queen Isabella was omitted. (Glass Ceiling?)

The Intrepid Museum carried the post-card series and posters in their gift shop as a tie-in for their exhibit and the lecture series I did for their Quincentenary years.

While the paintings were on exhibit at the Society of Illustrators, Steven Lee Myers of the *New York Times* asked if he could photograph the paintings for the Sunday Metro Section. It was a very exciting experience. He took pictures of the various Discoveres and then took a picture of each person who had posed for them.

Both Serf and I eagerly awaited the publication of the Sunday *Times* and upon opening it to the proper section found this great headline: GALLERY OF THE PAST, MIRROR OF THE PRESENT. It was wonderful!

Other newspapers also picked up on the paintings — *America Oggi, The Gazette, Queens Courier, The Ionian, Newsday.* One of the articles said, "At last we know what Columbus looked like. He looked like Senator Maltese."

"She has immortalized the Grand Navigators like Michelangelo in his Vatican masterpieces." ANTONIO CIAPPINA

"The artist has combined history, geography and heraldry . . . to create a sometimes mystical, sometimes profound and sometimes intriguing composite."

"She has taken their countenance and superimposed the soul of the historic character over them — truly masterpieces."

JIM MAHONEY

"Her crowning achievement . . . a legacy for future generations." ALEX BERGER

"Each portrait is literally surrounded by its history."

LINDA D'ALESIO

At taping of Channel 35's Senator Maltese's Public TV Show about his district and what's going on. Constance and Serf talk about the Quincentenary with John Emery of Senate Communications.

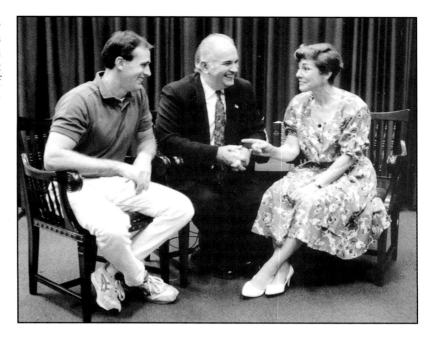

We could call it "Breakfast With Connie and Serf"

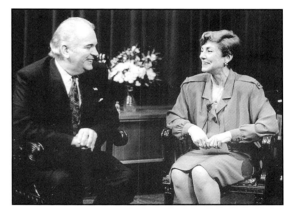

Constance, while on promotional tour in Florida for Columbus plates, visits WQBA Radio with Senator Maltese. WQBA was involved in promoting the Quincentennial celebration.

COURAGE

About the cover: The dramatic work shown on the cover of this collector's journal captures the darkest fear of the courageous navigator Christopher Columbus and those who sailed with him. It took an enormous amount of "Courage," which is what the work is appropriately titled, to sail unchartered waters into unexplored territory — sailing against the tide of popular belief which, at that time, said the earth was square. Yet, Columbus forged courageously ahead. On his long and weary voyage there must have been more than one occasion when he envisioned the picture of doom. The work depicts one of Columbus' ships falling off the earth, with the same ominous fate about to overcome the other vessels. Each vessel is flying a flag — one representing the Papal flag, another the Spanish flag flown during that period, and the third displaying Columbus' coat of arms on his native Genoa flag. The concept was designed and the work commissioned by Richard A. Grace, president of Grace Industries, Inc. The work was created by portrait artist Constance Del Vecchio Maltese (her biography appears below). This work will have a special place in the archives of the Quincentennial celebrations. It is truly a work of art that bridges the time and history of the Old and New Worlds.

Coalition of Italo–American Assns., Inc.
TENTH ANNIVERSARY LEADERSHIP AWARDS DINNER

Waldorf Astoria

SEPTEMBER 18, 1992

1992 was a very busy and exciting year. I was commissioned by Mr. Richard Grace, President of Grace Industries, to paint an oil he dubbed "Courage." He explained that he wished to portray the Nina, Pinta and Santa Maria making a voyage over the side of the world. Since it took a great deal of courage to sail into the unknown, it got the point across that these were indeed courageous men. I had six weeks to complete this painting, so I was really working against a heavy deadline. The cover of the book that it was made for was 9" x 12" and the painting was 30" x 42"!

I remember finishing the painting at my studio in upstate Westerlo, and after a full day of painting I was getting a little giddy. I decided to include a sailor at the side of the falls falling near his life boat, and after pondering this poor soul, made the decision to leave him in. Later, when the painting was displayed in the Empire State Building lobby for the Columbus Celebration, I saw a family of four standing in front of the painting. The little girl of about twelve said, "Look, Mom, that poor sailor is falling over!" I knew then that I had made the right decision. The point was made.

As for being able to depict the Nina, Pinta and Santa Maria, luckily the replicas were docked at the Intrepid Pier. I am no sailor and would never know where to put what rigging, but I had captive models for my painting and was able to see everything.

Thank you, Richard Grace, and the Italo-American Association.

AWARDS
PRESENTATIONS

During that same year (1992) I was named the WOMAN OF THE YEAR by the Italian American Business Association. Dr. Joseph Valletutti and Cavaliere Peter Cardella presented me with this opportunity, and expressed their desire to create a medal from the image of my Young Visionary. I admit that I really did not think it would be possible, since there was a great deal of detail in the background of the painting. However, they assured me they would take care of it and that the cast-maker was a genius.

They were absolutely right. It was the event of the event that they presented me with the finished product, and I was amazed. Every little detail, even the design around the painting, was depicted. With the help of my brother-in-law, Vincent, I have since had more of them made from the cast in sterling silver. They are beautiful!

Cavaliere Cardella presented me with the Medal that evening. He was instrumental in further promoting the Discoverer Series by supplying many organizations with the Quincentenary Cards. In most cases, especially with Italian American organizations, he provided them as his generous gift.

Unfortunately, Dr. Joseph Valletutti has since passed away, but I remember him as a generous and thoughtful gentleman, eager to do everything possible to enhance the Italian American image.

➥ Dr. Joseph Valletutti, Senator Serphin Maltese and Cavaliere Peter Cardella

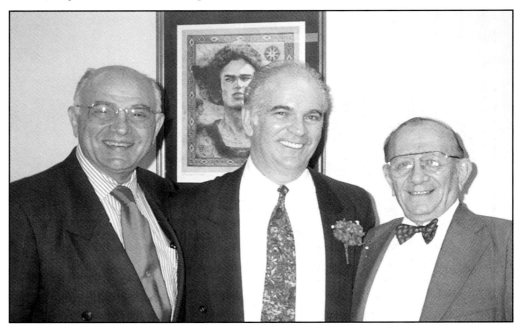

It was an exciting evening at Italian-American Businessmen's Association.

Constance autographs a Columbus poster for a guest at the Award Dinner.

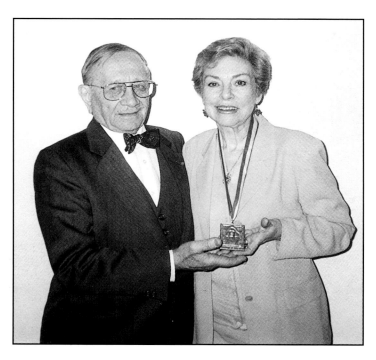

Cavaliere Peter Cardella bestows the "Woman of the Year Award" (Columbus Medal) to Constance Del Vecchio-Maltese.

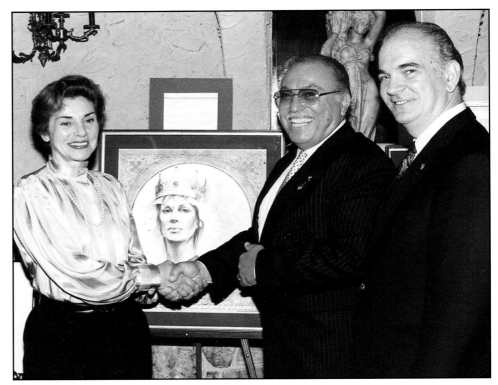

Mr. Frank Barone
congratulates Constance
for her Discoverer series
as Serf looks on.

SONS OF ITALY Honors
Constance Del Vecchio/Maltese
At Quincentenary Dinner

Constance proudly holds award
presented to her at the Mario Lanza
Lodge on October 23, 1992.

Left to right: Claudia Massimo Berns, Dr. Joseph Scelsa, Lt. Gov. Mary O. Donohue, Prof. Joseph Tusiani, Consul General Giorgio Radicatti, Gov. George Pataki and Constance D. Maltese.

Constance is congratulated by Mr. Paul Pope and his guest as Serphin beams with approval.

◆ Left to right: Salvatore Crifasi holding commemorative plate, Senator Serf Maltese, Senator Alfonse D'Amato, Constance D. Maltese, Frank D'Orazi holding Magellan plate, and Conservative Party Chairman Michael Long.

There were many occasions for the Discoverers to make an appearance . . .

Constance presents a group print of Discoverers at Italian Roundtable Dinner.

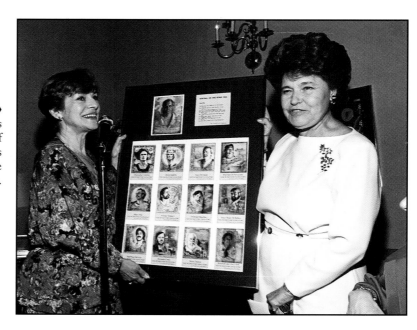

I can actually say, "God, I love this job." It was in late 1991 that Serf said he was going to Puerto Rico as part of the Puerto Rican Hispanic Task Force mission. Would I like to come along and present my plates and prints to dignitaries in Puerto Rico? What do you think? I was delighted with the trip, Puerto Rico, the people I met there, and the people I traveled with. What a fantastic time! I can't say enough about the country and how we were treated there.

We were asked to the Governor's Mansion and were treated royally at a marvelous reception. It was at this time that we made the presentation to Lieutenant Governor Antonao Colorado of the Juan Ponce de Leon Print. When he accepted the Print, he bestowed

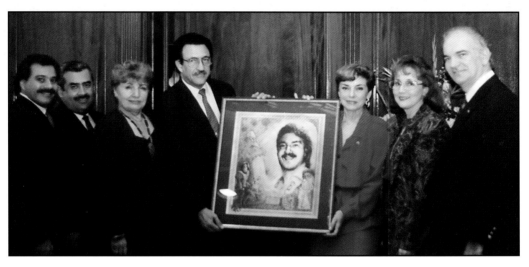

◆ A presentation of the first Governor of Puerto Rico, Juan Ponce de Leon, is made to the Lieutenant Governor Antonao Colorado of Puerto Rico during our trip to Puerto Rico in November 1991. Present are Assemblyman Felix Ortiz, Senator Efrain Gonzalez, Senator Olga Mendez, Lieutenant Governor Colorado, Constance D. Maltese and Senator Serphin Maltese.

on me the title of Honorary Puerto Rican. This is a title I accepted with great humility.

It was on this trip that I got to know Senator Efrain Gonzalez and Senator Olga Mendez even better than before, and have since had the pleasure of painting portraits of them both.

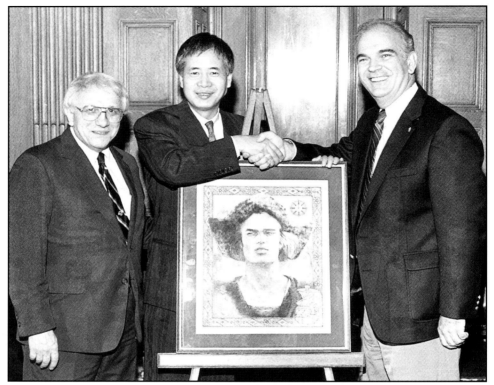

Former Senator Tarky Lombardi, Haruki Kadokawa of Japanese Santa Maria Committee, receiving our Young Visionary from Senator Maltese.

. . . The Encounter
Of Two Worlds . . .

Assemblymen
Denis Butler,
Jerry Nadler and
Morton Hillman
with Senator Maltese
and the Young Visionary.

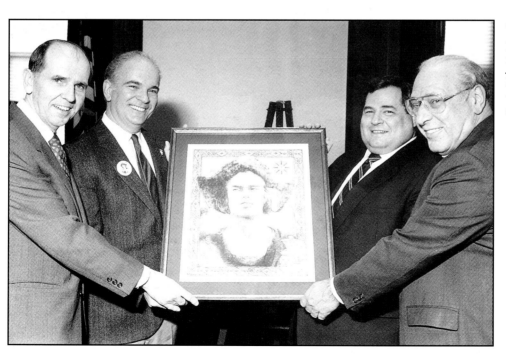

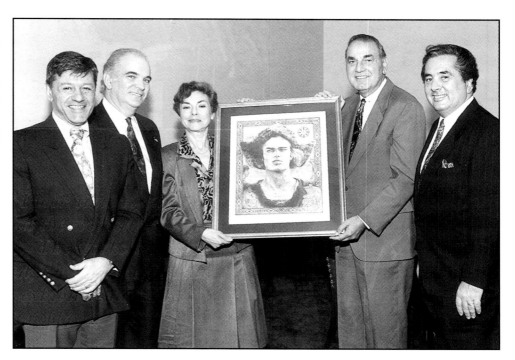

Judge Chris Mega, Serphin Maltese and Constance D. Maltese presenting "Young Visionary" to Senate Republican Majority Leader Ralph Marino and Senator Guy Velella.

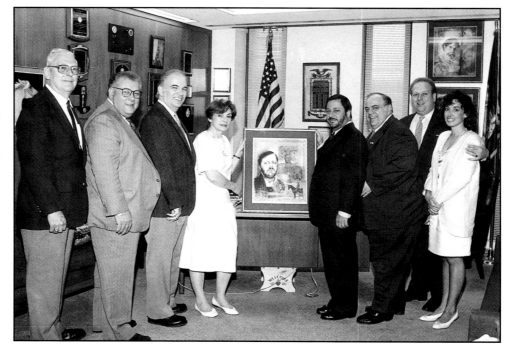

Veterans leader Arthur Dunkelman, Assemblyman Anthony Genovesi, Senator Maltese and Constance D. Maltese presenting Cortes painting to model Tom Catapano, with assist from Assemblyman Anthony Seminario, Senator Nicholas Spano, and Carla Tarenzi.

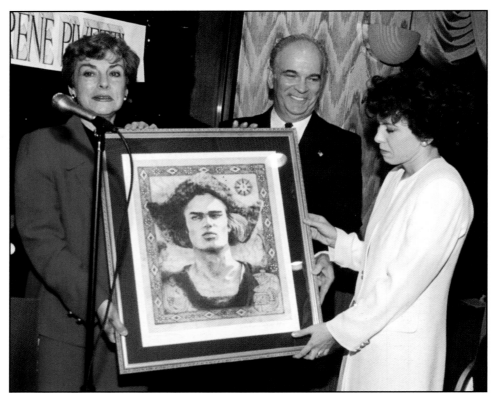

Constance and Serphin present painting of Columbus to the Honorable Irene Pivetti. the President of the Chamber of Deputies of Italy.

Italian politics are very complex. It was explained to me that there are many political parties at various levels in all sections of Italy. Italy boasted a very charming and intelligent woman President of their parliament. Her name, Irene Pivetti. She was coming to the United States and Serphin had invited her to visit Christ the King High School, where Serf serves as Chairman of the Board. She was interested to see an American Roman Catholic High School, visit with the children, and extend good wishes from Italy to the youth of America.

I accompanied Serphin in greeting President Previti and escorting her through the school. The glee club sang a medley of Neapolitan songs and she was accorded a wonderful reception. The entourage proceeded to one of our finest Italian American restaurants, Pat's, on Grand Avenue, and feasted on a series of marvelous courses. there I extended our formal good wishes with my Print of the Young Voyager.

It wasn't until the last Columbus Countdown; 92 Dinner that I was able to present my final painting, "Admiral of the Ocean Sea" — the older Columbus. Adriana Scalamandre-Bitter was the guest of honor and recipient of the Print. I knew Adriana as Terry when we both attended Parson's School of Design. It was with a great deal of pleasure that after all these years I was able to include her in our grand celebration of Columbus. It was her father that earlier founded Scalamandre Silks. Now that distinguished name has been passed on to Adriana — a legacy that she proudly continues.

COLUMBUS COUNTDOWN: 92
Dinner Presenting Final Painting
To Adriana Scalamandré

Dr. Frank Grande,
St. John's University Vice
President Joseph Sciame,
Dr. Anne Paolucci
and Constance D. Maltese

Constance addressing
schoolmate
Adriana Scalamandré Bitter
with Queens Deputy
Borough President Peter
Magnani looking on.

POPE JOHN PAUL II

It just gets better and better! Serphin is now the President of the Italian-American Legislators. It was decided it would be wonderful to make a trip to Italy as a Legislative group. We would be able to see the various parts of that beautiful country. Sicily and Rome were on the agenda. We were a group of approximately thirty, anxious to visit all the points of interest, eat all the great foods and drink the exquisite wines. Of course, meeting the different government officials and visiting the seats of power were on the agenda as well. Reverend Monsignor George Cascelli, Director of the Italian Apostolate for the New York Archdiocese, was with us on our mission and he was going to try to obtain an audience with the Pope. Naturally, we all thought this would be awesome, even though we were aware that it would be together with a cast of thousands.

Little did we know that on that wonderful day we would be invited on the platform where our Pontiff, Pope John Paul II, was to be seated and make his address. But there we were, unable to believe it, and more unbelievable was his approach to meet with us, at which point I was able to present him with my Columbus Plate, suitably inscribed as our Legislative group's gift. Needless to say, both Serf and I were speechless, but ever so grateful for what can only be described as the experience of a lifetime!

VIVA ITALIA! VIVA COLUMBUS!